HARRY & MEGHAN

The ROYAL
WEDDING
ALBUM

THIS IS A CARLTON BOOK

Published in 2018 by Carlton Books Limited
20 Mortimer Street
London W1T 3JW

10 9 8 7 6 5 4 3 2 1

Text © Carlton Books 2018
Design © Carlton Books 2018

A CIP catalogue record for this book is available from the British
Library.

ISBN 978 1 78739 134 5

Printed in Spain

HARRY & MEGHAN

The ROYAL WEDDING ALBUM

ANGELA PEEL

CARLTON BOOKS

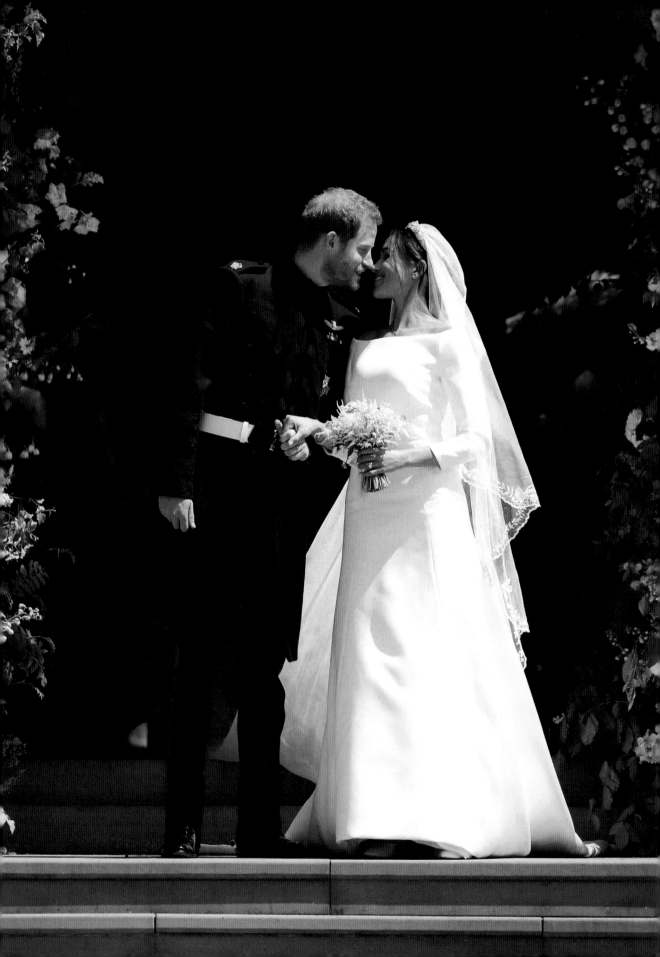

CONTENTS

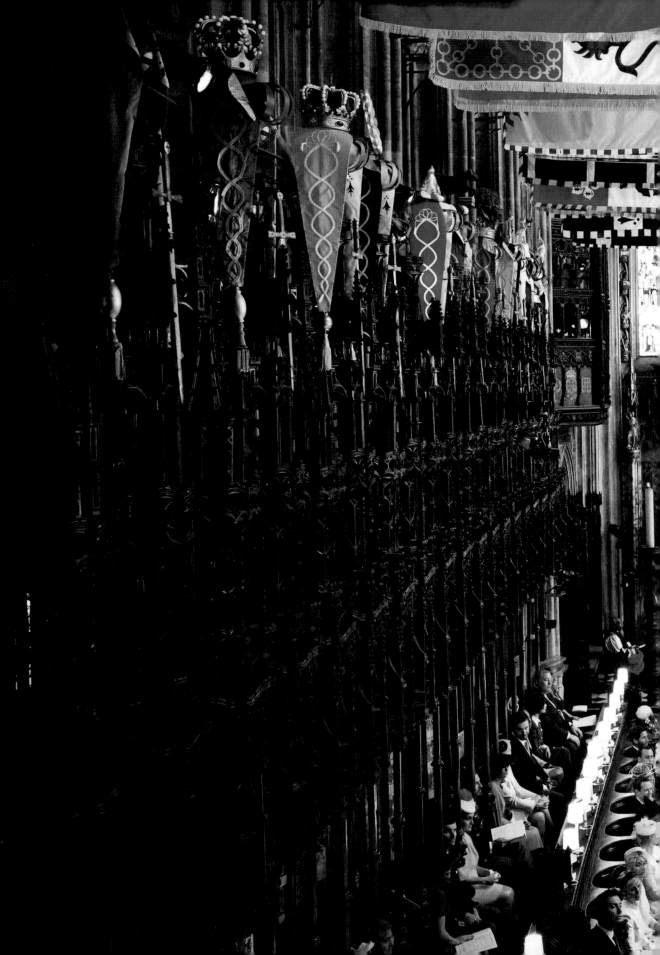

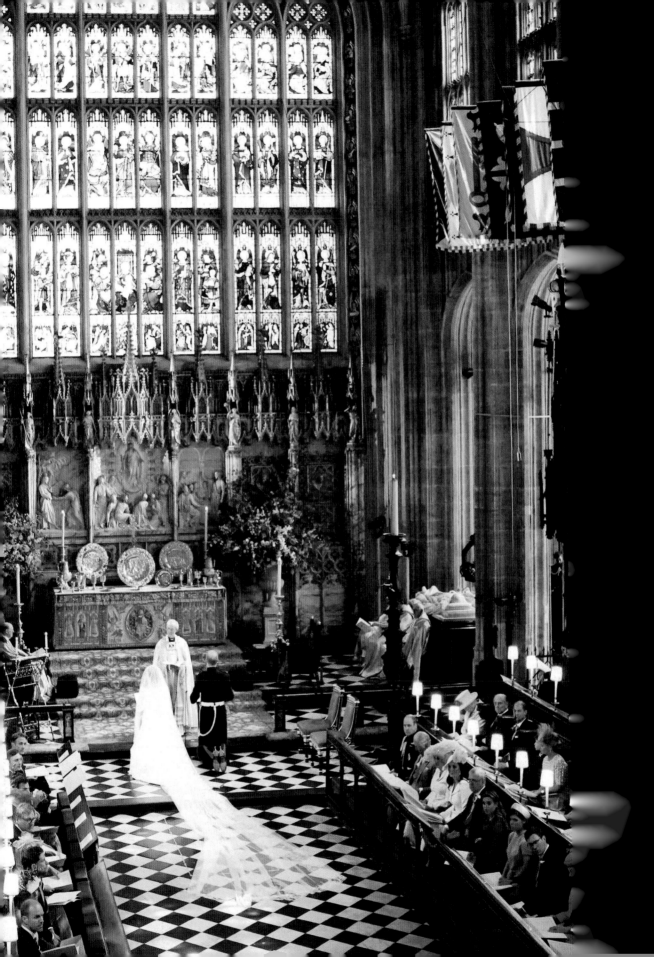

INTRODUCTION

The wedding between Henry Charles Albert David Windsor and Rachel Meghan Markle is simply unprecedented in almost every conceivable way. When Harry's own parents married, it was deemed that the bride must come from a suitable background and have had no other significant suitors in her background. Princess Diana made the grade because she was too young to have had any other serious boyfriends, and because her forebears, the Spencers, were one of Britain's most prominent aristocratic families and her father had been an equerry to the King.

Meghan Markle could not be more different. A biracial actress who has already been married once and who comes from the United States, she will be 36 on the day she marries Harry – the same age Diana was when she died. But their union has not only failed to raise any eyebrows, regal or otherwise, it has been warmly welcomed, both by the Royal Family and the rest of the country. It is an indication as to quite how much the monarchy has changed since 1981, the year Harry's parents got married, although then, as now, it is still the Queen who is in charge.

The Windsors have, in fact, been adept at constantly reinventing themselves throughout their history and have done so again in the second decade of the twenty-first century – twice. The wedding of Harry's older brother, William, was already a step away from tradition in that his bride, Catherine Middleton, was, herself, a middle-class girl, not a member of the aristocracy or any foreign royal family. The two lived together before getting married – an unprecedented occurrence. But the circumstances surrounding Harry's marriage are more unusual still.

In 1936, the monarchy was shaken to its very foundations when another American divorcee, Wallis Simpson, caused Edward VIII, Harry's great-great uncle, to abdicate the throne. The crown went to his younger brother, George VI, father of the present Queen, but it was that abdication that rocked the nation to such an extent that Elizabeth II will not, despite her great age, countenance standing

down today. To the Windsors, duty is everything and Edward did not do his duty. It would not have been surprising if there had been a judder of terror when Meghan arrived on the scene.

But there wasn't. Of course, circumstances have changed: the world, as well as the House of Windsor, has moved on. Nor is Harry in the same position as Edward VIII: by the time of the wedding, he will be sixth in line to the throne, not the incumbent. It is very unlikely that Harry will ever become Henry IX.

But he is, and will remain, a senior Royal and, as such, his choice of bride will always attract a huge amount of attention. And that Meghan is so markedly different from other Royal brides shows quite how much attitudes have changed. For the great irony, of course, is that, while the abdication crisis was caused by a divorcee, divorce has featured in the Royal Family in almost every generation since. The Queen's sister, Princess Margaret, was forced to give up the great love of her life, Peter Townsend, on the grounds that he was divorced, only to later split from her own husband, the Earl of Snowdon. Three of the Queen's children are divorced, including Harry's father, Prince Charles. Lessons have clearly been learned, as the Queen put it in another context, and now, rather than forcing the Royal princes into quasi-arranged unions, they have been allowed to marry for love.

And so, as with his older brother, William, Harry could not only choose his own bride regardless of background, but protocol has been relaxed to the extent that Meghan was able to spend Christmas with him at the Queen's Norfolk home in Sandringham (again unprecedented before the actual wedding – even Kate had to wait to become the Duchess of Cambridge before that honour was extended to her) and relax into life at Nottingham Cottage (Nott Cott), their home in the grounds of Kensington Palace. And Meghan is clearly the right choice for him. This book will look at the background of both of them, of what shaped them, and of why they are so compatible. They are the ultimate modern Royal couple – and this is why.

CHAPTER 1

PRINCE HARRY

"I'VE LONGED FOR KIDS SINCE I WAS VERY, VERY YOUNG. AND SO . . . I'M WAITING TO FIND THE RIGHT PERSON, SOMEONE WHO'S WILLING TO TAKE ON THE JOB."

PRINCE HARRY, NOVEMBER 2017

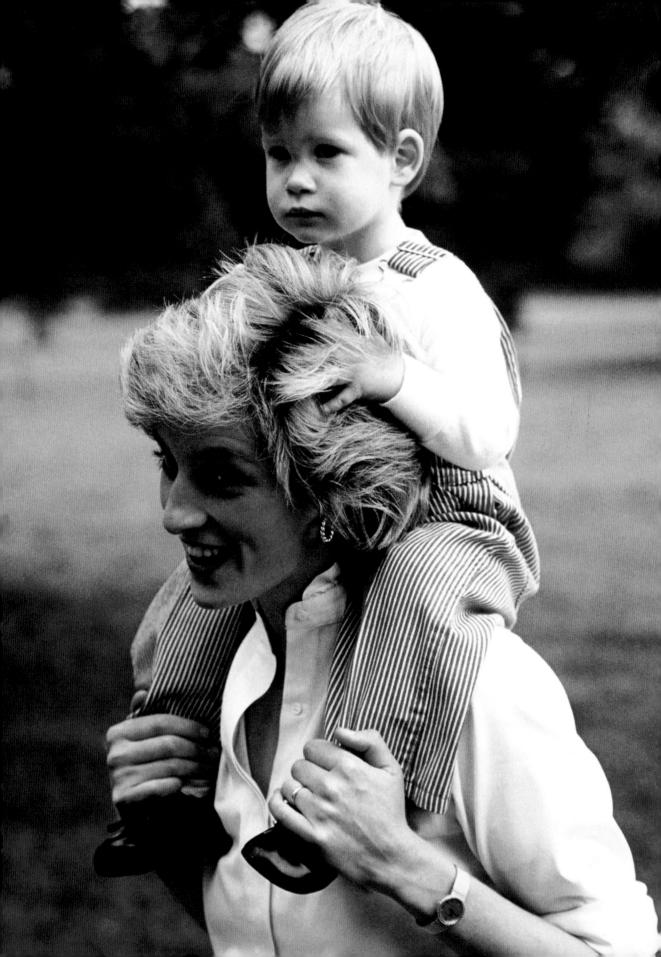

His birth, when it came, marked yet another high in the Royal Family's fortunes in the early 1980s. Prince Henry Charles Albert David was born on 15 September 1984 in the Lindo Wing of St Mary's Hospital in Paddington, London. Known as Harry right from the start, he was the second son of Prince Charles and Princess Diana, and (at that stage) third in line to the British throne. To the public, it was a huge cause of celebration and appeared to be a sign of the happiness between Charles and Diana; in private, alas, it was a different story. But no one knew it back then.

Little Harry was baptized into the Church of England by the Archbishop of Canterbury, Robert Runcie, and sent to Mrs Mynors' nursery school and pre-preparatory Wetherby School in London. This was followed by Ludgrove School and Eton, both of which were also attended by his elder brother, William. Away from school the brothers divided their time between Kensington Palace and Highgrove, their parents' homes in London and Gloucestershire. Harry was introduced to public life early – his first official trip happened in 1986 when he was taken to Italy.

Behind the scenes, however, matters were far more complicated than the public realized at the time. Harry's mother, Diana, far from being the pliable spouse that she had initially seemed destined to be, was turning into the most famous and most photographed woman in the world. There was a big age gap between her and Charles – when they married, she was 20 and he was 32 – and it further emerged that they had little in common. Moreover, Diana was determined to bring her sons up in a way that was brand new to the Royal Family, taking them to homeless shelters, exposing them to the less fortunate in life. Both boys grew up understanding that theirs was a privileged

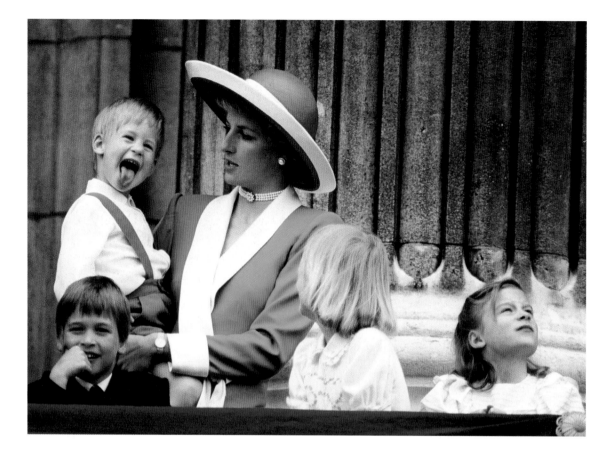

life; in later years it also became clear that Harry had inherited his mother's empathy when dealing with people born without the same advantages he had in life. He also inherited her rebelliousness: Harry was a mischievous little boy, far more so than his staid older brother, and was known to lead his Royal protection officers a merry dance. There were trips to the Caribbean, to Florida's Disney World, to Alton Towers. They were probably the first Royal princes to be taken to McDonald's, just down the road from Kensington Palace.

But his childhood had its own fair share of travails, which would culminate in tragedy. As his parents' marriage fell apart, both pursued other relationships: Diana with James Hewitt and Charles with his first great love, Camilla Parker Bowles, whom he would later go on to marry. Stories began to leak out into the press about the terrible state of the Wales's marriage and, in 1992, the publication of *Diana: Her True Story* blew the idea of the Royal marriage as a real-life fairy tale out of the water. The couple separated, and Prince Charles moved out to St James's Palace. While Kensington Palace remained Harry's London home,

Harry was always the naughty one. Here he is sticking his tongue out on the royal balcony following the Trooping the Colour parade. Lady Gabriella Windsor and Lady Rose Windsor are also present.

Harry's first day at Wetherby School, which William also attended.

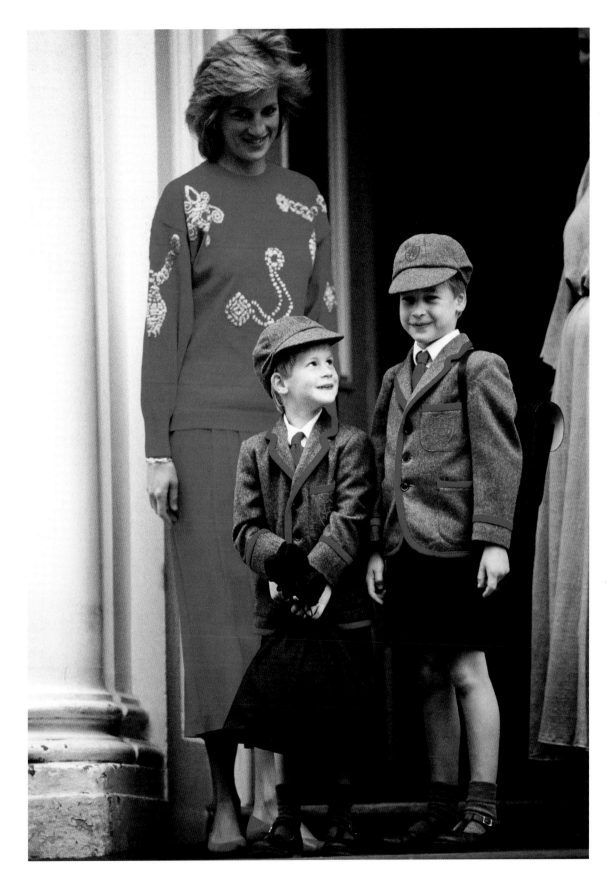

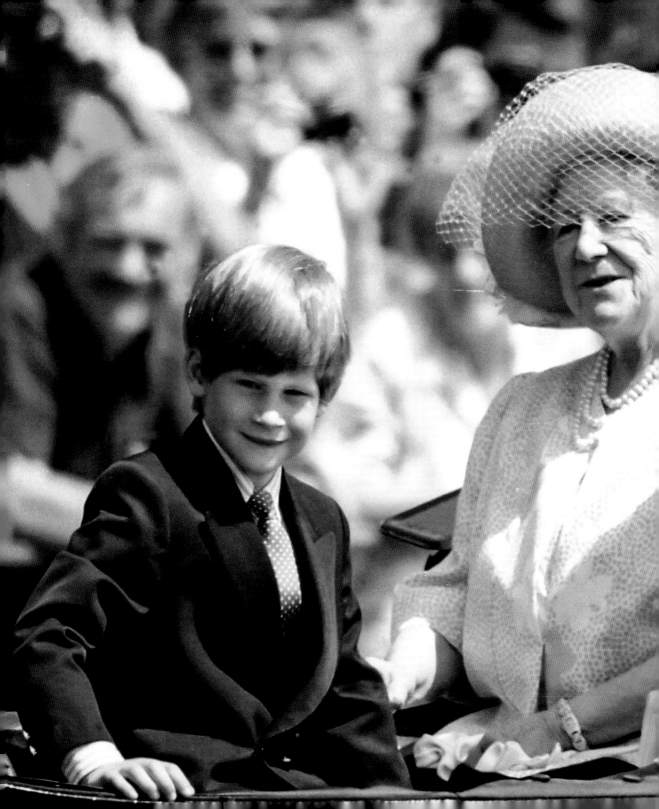

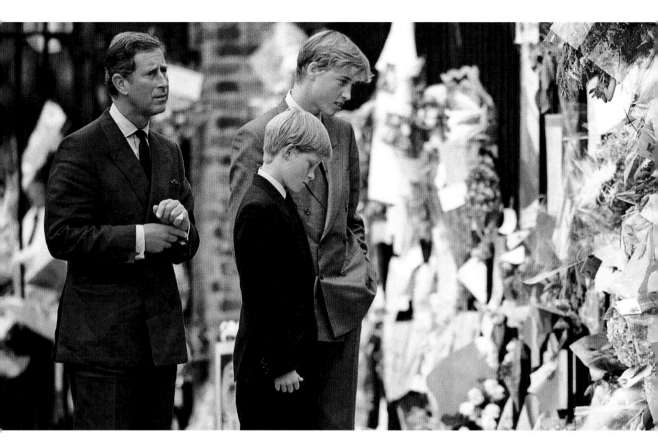

PREVIOUS PAGE:

All his life, Harry has been exposed to grand state ceremonial occasions, and he is pictured here in the Trooping the Colour ceremony in 1992. With him in the carriage are his mother, Princess Diana, and his great-grandmother, Queen Elizabeth The Queen Mother.

he still spent time with his father in the country, keeping pets and learning countryside pursuits. From 1993, he and William had a de facto nanny in the jolly shape of Tiggy Legge-Bourke, who was, herself, the source of controversy when she said of her charges, "I give them what they need at this stage: fresh air, a rifle and a horse. She [Diana] gives them a tennis racket and a bucket of popcorn at the movies." She further irritated Diana by referring to the two of them as "my babies".

In 1996, Harry's parents divorced and, the following year, the great tragedy of his young life occurred. He was just 12 years old when his mother was killed in a car crash in Paris with her lover Dodi al Fayed. The hearts of the nation went out to the bereaved little boy as they saw him walking alongside his brother, father, grandfather and uncle Charles Spencer behind the funeral cortège as it moved from Kensington Palace to Westminster Abbey. In later years, he was to talk of the huge gap in his life after losing his

ABOVE:

In the aftermath of Princess Diana's shocking death, Prince Charles takes his two young sons to inspect the massive floral tribute left outside Kensington Palace.

mother at such a young age, of the anger it built up and the sadness he was unable to cope with. It created the need in his life for a mother figure and it is, perhaps, not surprising that his eventual fiancée was a couple of years older than him and with a very maternal, cherishing air. In the wake of Diana's death, Harry and William continued in the care of Tiggy Legge-Bourke, who again managed to cause controversy when she allowed the princes to abseil down a 50-metre dam without safety lines or helmets. That might have been it for Tiggy, but the boys adored her so much that she retained her position after all.

There were signs of rebellion, even then. Harry was just 17 when he was photographed smoking cannabis and drinking (underage), provoking his father to take him to a drugs clinic to see what could happen if a problem really got out of hand. There was further trouble when he unwisely wore a Nazi German Afrika Korps uniform complete with a swastika armband to a fancy-dress party, for which he later apologized. However, despite the lack of judgement on his part, there was widespread sympathy among the public. This was a young man who had lost his mother and, even before Harry spoke about the impact of what had happened to him, as he only did many years later, there was an understanding that, if Harry was sometimes a little too outrageous, it was because, despite Tiggy's efforts, the guiding hand of a mother was not there.

In June 2003, Harry left Eton with two A-levels, which qualified him to join the army, and, after a gap year in Australia

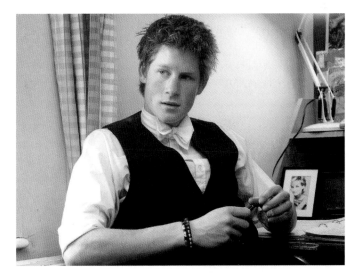

LEFT:

A pensive-looking Prince Harry in his room at Eton. A photo of his mother sits on the desk behind him.

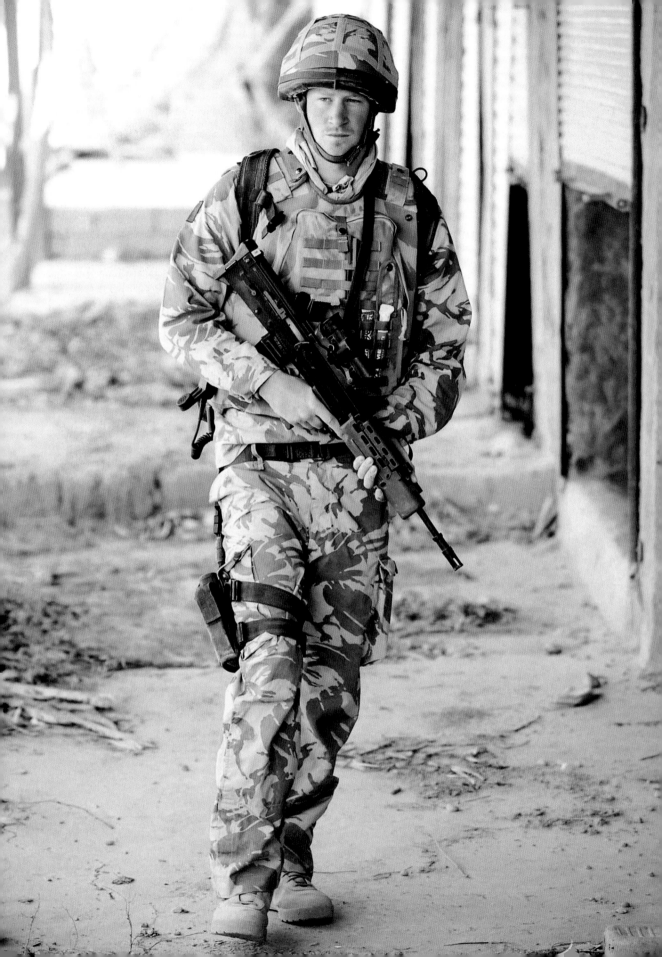

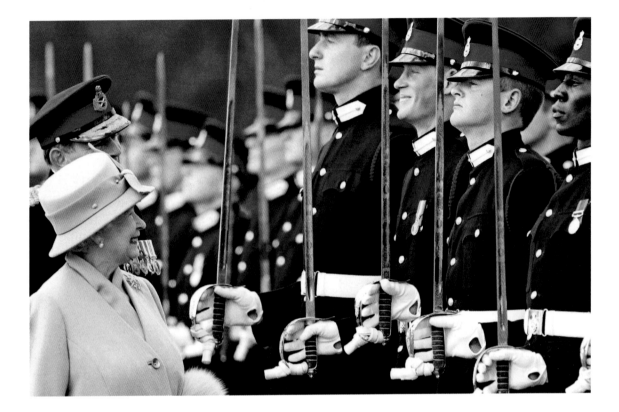

OPPOSITE:

Prince Harry distinguished himself as a soldier when serving in Afghanistan. Here he is holding a self-loading rifle while on patrol in the deserted town of Garmsir.

ABOVE:

A prince on parade. The Queen smiles at her grandson as she inspects soldiers at the Sovereign's Parade at Sandhurst.

in which he worked on a cattle ranch, he entered Sandhurst in May 2005. Officer Cadet Wales, as he was known, joined the Alamein Company and, after completing his officer training within a year, was commissioned as a cornet in the Blues and Royals. The army was the making of him. In his spare time, Harry was developing the reputation of being something of a party prince, photographed falling out of nightclubs and fighting with photographers – a direct result, it is clear in hindsight, of losing his mother so young – but no one doubted his bravery and commitment to the armed forces. There was early debate about whether he should be allowed to serve in Iraq – Harry, himself, was very keen to see action, saying, "If they said, 'No, you can't go front line,' then I wouldn't drag my sorry ass through Sandhurst and I wouldn't be where I am now." Ultimately, however, it was deemed that he and the soldiers around him would be too much at risk as a high-profile target but, in October 2008, like his father and brother before him, it was announced he would learn to fly military helicopters. After learning to fly

the Apache attack helicopter, he was presented with his wings by his father in 2010.

Harry proved to be a very adept Apache pilot and, after further training in California and Arizona in 2012, he went to serve on a four-month combat tour of Afghanistan. He was threatened by the Taliban, but served for 20 weeks, having successfully qualified as an Apache aircraft commander. Back in London, he became a staff officer and, at the same time, conceived the idea for the Invictus Games, a Paralympic-style event for injured members of the Armed Forces, which is how he was to meet one Meghan Markle. The inaugural games were held on 10–14 September 2014 and are probably Harry's most impressive contribution to public life to date.

After a secondment to the Australian Defence Force, Harry left the Armed Forces in June 2015. But, apart from his ongoing involvement with the Invictus Games, he had taken on numerous other roles. He had been appointed Counsellor of State when he was just 21 and, as such, was heavily involved in the Commonwealth. Nor were the Invictus Games his only work for the underprivileged. Harry had early conceived of a great love for

BELOW:

Prince Harry set up a charity, Sentebale, to help vulnerable children in Lesotho. Here he is playing with a three-year-old blind girl named Karabo while visiting the Phelisanong Centre, Pitseng, in December 2014.

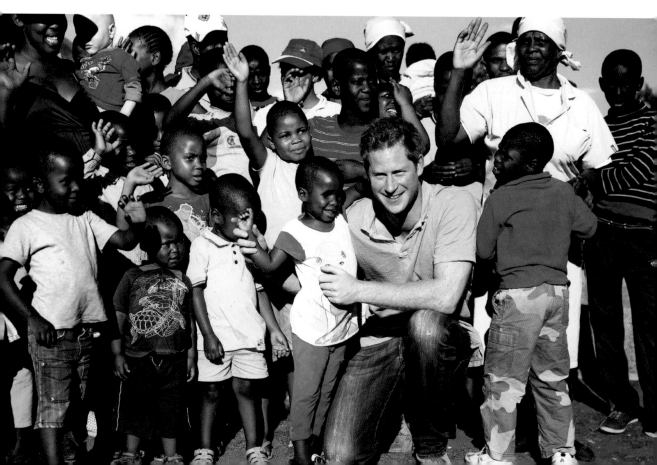

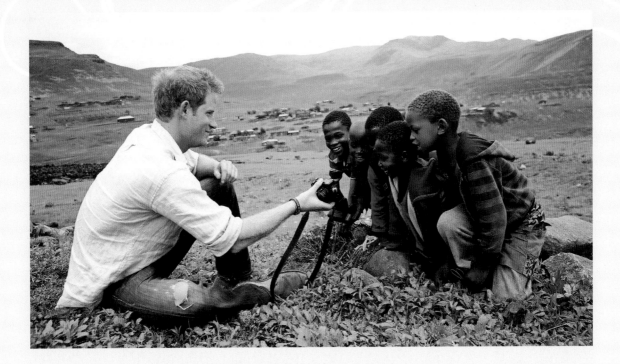

Africa, and the plight of the people in the former British colony of Lesotho had touched him deeply. As early as 2004, he launched Sentebale: The Princes' Fund for Lesotho, to help children with HIV/Aids, and, in 2007, organized the Concert for Diana at Wembley Stadium to help fund it. There have been numerous other charitable involvements as well, including WellChild and polo matches in aid of various causes.

In 2009, Harry and William set up their own Royal household in St James's Palace, separate from their father's, guided by the former British ambassador to Washington, Sir David Manning, and that year also launched The Foundation of Prince William and Prince Harry to further their charitable work. Harry's immense popularity was growing both at home and abroad: in March 2012, as part of the Queen's Diamond Jubilee Celebrations, Harry visited Belize, the Bahamas and Jamaica, where his presence went down so well that he was even credited with stopping the prime minister, Portia Simpson-Miller, from cutting the ties between Jamaica and the monarchy. Numerous international visits were to follow, with Harry as one of the most senior members of the Royal Family representing the Windsors all over the world.

In 2012, there was also a return to controversy, when pictures of Harry and an unknown young woman – both naked in a Wynn

ABOVE:

On the same visit, he went to Mokhotlong, where he showed children a photo he had taken on a Fuji X100s camera.

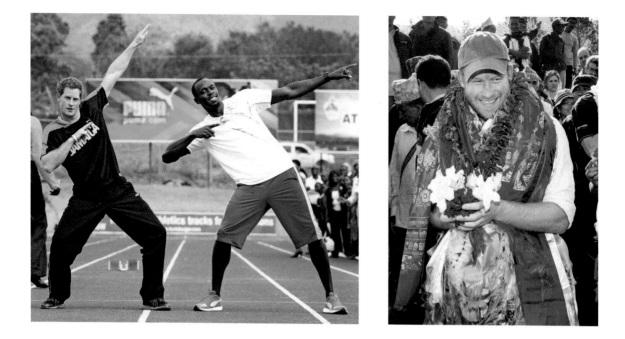

PREVIOUS PAGE:

Prince William arrives at Westminster Abbey on his wedding day with his brother and best man Prince Harry.

ABOVE LEFT:

Prince Harry charmed Jamaica when visiting for Queen Elizabeth's Diamond Jubilee. Posing with Usain Bolt, Harry later raced the sprinter.

ABOVE RIGHT:

Laden with garlands on a visit to Gauda Secondary School, which had been damaged by an earthquake in Okhari, Nepal.

Las Vegas hotel room playing strip billiards – emerged. Initially, UK newspapers were reluctant to publish the photos, although the *Sun* ultimately did so, while St James's Palace maintained that Harry's privacy had been invaded. It made no difference whatsoever to his standing, with the public polls later that year showing Harry to be the third most popular member of the Royal Family after the Queen and Prince William.

He was also one of the most eligible men in the world and was to have two serious relationships before meeting Meghan. The first of these was Chelsy Davy, daughter of the (controversial) Zimbabwean businessman Charles Davy. The two were together for about seven years, between 2004 and 2011, with a gap in the middle. In an interview that took place to coincide with his twenty-first birthday, Harry commented that he "would love to tell everyone how amazing she is but once I start talking about that, I have left myself open… There is truth and there is lies and unfortunately I cannot get the truth across."

Chelsy accompanied him to the wedding of William and Catherine Middleton but, ironically, that was said to have brought it home to her that they could not marry because she could not cope with the pressures of such a public life. "She has watched what Kate has gone through and how much she has had to sacrifice, and says it's not for her," a friend of hers said. "Chelsy thought the wedding was wonderful and she had a ball, but there's no way marriage is on the

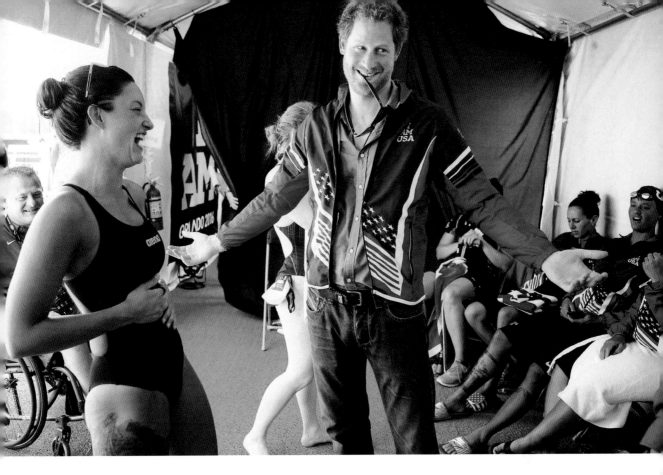

cards for her. She wants her freedom and to start a career. That's her focus at the moment, she and Harry are going to see how things go." In the end, of course, they split up, and Harry embarked on a two-year relationship with the actress Cressida Bonas, after being introduced to her by his cousin, Princess Eugenie. Cressida, too, found it difficult to cope with being in the public eye and in April 2014 it was announced that there had been an amicable split. Harry was alone again.

Despite his eligible-man status, it was to be a while before Harry finally found the woman he was destined for, not least because any women knew that, by dating him, they would be the subject of a good deal of attention, which put them off. "If or when I do find a girlfriend, I will do my utmost to ensure that me and her can get to the point where we're actually comfortable with each other before the massive invasion that is inevitably going to happen into her privacy," he told the *Sunday Times*. "The other concern is that even if I talk to a girl, that person is then suddenly my wife, and people go knocking on her door." In other words, Harry needed to find someone who could handle the spotlight. And he did.

ABOVE:

Prince Harry chats to USA Invictus Team Member Elizabeth Marks during the Invictus Games Orlando 2016 before trying on her jersey. One of Harry's proudest achievements was establishing the Invictus Games to help injured and disabled people.

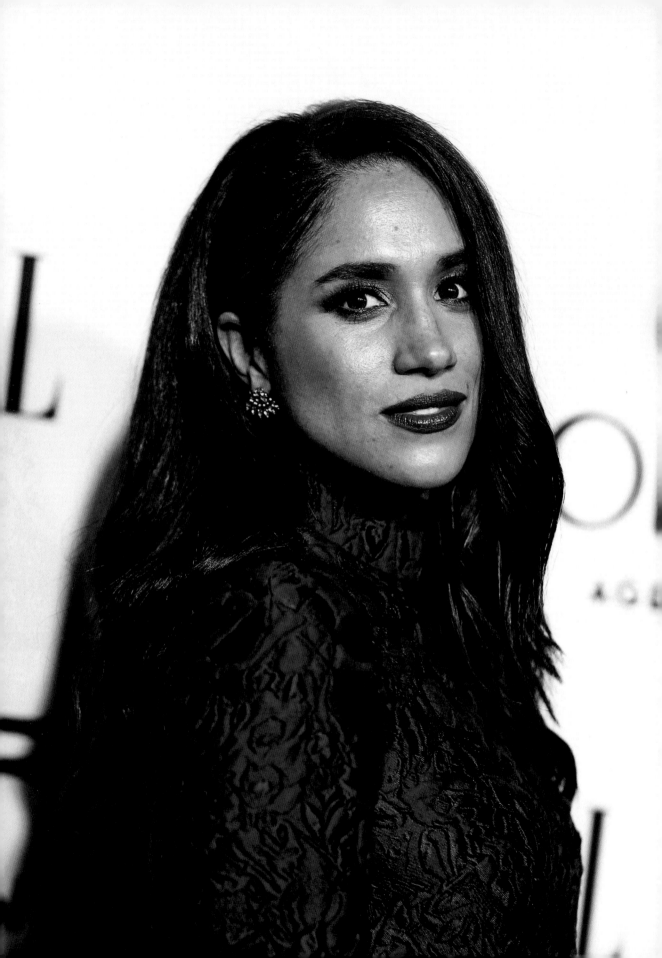

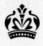

CHAPTER 2

MEGHAN MARKLE

*"REFLECTING ON WHERE I CAME FROM
HELPS ME TO APPRECIATE AND BALANCE
WHAT I HAVE NOW."*

MEGHAN MARKLE, DECEMBER 2016

When Thomas W. Markle and Doria Ragland first set eyes on one another at some point towards the end of the 1970s, they could not have dreamed that one day their daughter was going to marry a prince of the House of Windsor. Indeed, even the life she had before she met Harry would have seemed a lot to grasp: actress in a hit TV show and with a reputation as a humanitarian. Hers was to be an active life.

In fact, the couple's union raised eyebrows even then in some eyes, because Doria is African American and can trace her forebears back to slaves (an even more remarkable precedent in a Royal bride than Kate Middleton's coal-mining ancestors), while Thomas came from Dutch-Irish stock. Thomas had been married before, giving Meghan an older half-brother and half-sister, and by the time his daughter came along on 4 August 1981, he was working as a lighting director in Los Angeles. Meghan was aware from the start that her status as a biracial woman caused comment:

"My dad is Caucasian and my mom is African American," she said in later years. "I'm half black and half white ... I have come to embrace [this and] say who I am, to share where I'm from, to voice my pride in being a strong, confident, mixed-race woman."

Shortly after her relationship with Harry came to light – and, with it, a renewed focus on her racial identity – Meghan tackled the subject head on in *Elle*. "It was the late Seventies when my parents met, my dad was a lighting director for a soap opera and my mom was a temp at the studio," she wrote. "I like to think he was drawn to her sweet eyes and her Afro, plus their shared love of antiques. Whatever it was, they married and had me. They moved into a house in The Valley in LA, to a neighbourhood that was leafy and affordable. What it was not, however, was diverse. And there was my mom, caramel in complexion with her light-skinned baby in tow, being asked where my mother was since they assumed she was the nanny."

It did, at least, tackle the elephant in the room because this was new and uncharted territory, although for Meghan it was an issue she'd had to deal with throughout her entire life. And it wasn't always easy. While growing up at school, she was asked to tick a box identifying her racial background (she couldn't) and, when her father found out why she was so upset about it, he advised her

BELOW:

High-school yearbook photographs of young Meghan. She had a love of performing from a young age.

to draw her own box in the future (which she most certainly did as an adult in life). Her parents did what they could, buying two sets of dolls – one black and one white – and combining them to create a mixed-race family, but the sensitivity to the subject remained.

The couple divorced when Meghan was just six, but she remained close to her father, visiting him on the set of *Married… with Children*, where he was the lighting director. She was thus given a taste for acting from an early age. She was educated at the Immaculate Heart Catholic High School, which wrongly gave some people the impression that she was a Catholic (both parents were Protestants) and, early on, she picked up some of the interests that were to stay with her into later life. Doria was a yoga teacher and she and Meghan would practise yoga together, as they still do. They also travelled from early on, and Meghan's philanthropic streak came out when she was as young as 13 and helped out in a soup kitchen.

"I started working at a soup kitchen in Skid Row of Los Angeles when I was 13 years old, and the first day I felt really scared," she told *The Game Changers*, a book by Samantha Brett and Steph Adams. "I was young, and it was rough and raw down there, and though I was with a great volunteer group, I just felt overwhelmed. I remember one of my mentors [Mrs Maria Pollia] told me that 'life is about putting others' needs above your own fears.' That has always stayed with me." It was to stand her in good stead. She was an early campaigner as well, managing to get a company to change a national television commercial at the age of just 11 because she believed it was sexist. One of her first jobs was earning $4 an hour at Humphrey Yogart, a frozen yoghurt store in LA: "Meghan was still at school – maybe a little older than 13 as the rules are strict in California," her boss Paula Sheftel later recalled. "She earned minimum wage and was very popular with customers. She had to prove she had an outgoing personality and would work well with staff."

After leaving school, Meghan attended Northwestern University in Evanston, Illinois, where she studied theatre and international studies and, partly because of the latter, spent some time as an intern at the US embassy in Buenos Aires, before deciding to opt for an acting career. But it was tough, not least because of the issue of ethnicity: "I wasn't black enough for the black roles and I wasn't white enough for the white ones, leaving me somewhere in

OPPOSITE:

A thoughtful looking Meghan attends the Some Kind-a Gorgeous Style and Beauty Lounge at the Chateau Marmont in California, 2010.

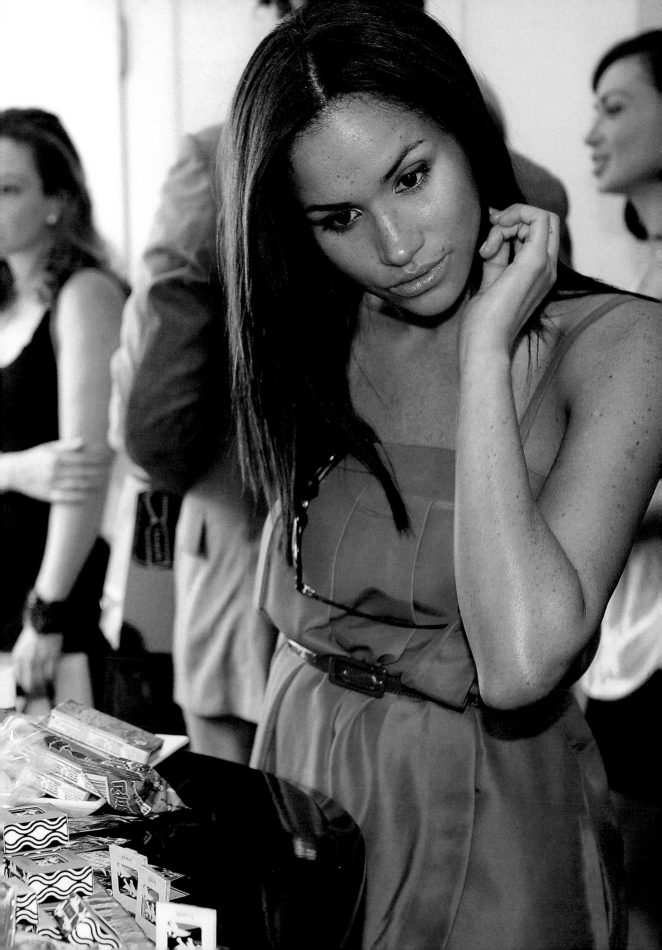

the middle as the ethnic chameleon who couldn't book a job," she later said. To help make ends meet, Meghan became a freelance calligrapher: "It was because I went to an all-girls Catholic school for, like, six years during the time when kids actually had handwriting class," she later told *Esquire*. "I've always had a propensity for getting the cursive down pretty well. What it evolved into was my pseudo-waitressing job when I was auditioning. I didn't wait tables. I did calligraphy for the invitations for, like, Robin Thicke and Paula Patton's wedding."

But work gradually began to come in. Her first television appearance was on the daytime soap *General Hospital*, then small roles on the likes of *Century City*, *The War at Home* and *CSI:NY* came in. Meghan also became a "briefcase girl" on the US game

show *Deal or No Deal*, something that came back to haunt her when her relationship with Harry came out and cheesy pictures of Meghan emerged, brandishing her suitcase. She often sounded a little embarrassed talking about that: "I would put that in the category of things I was doing while I was auditioning to try to make ends meet," she told *Esquire*. "I went from working in the US Embassy in Argentina to ending up on *Deal*. It's run the gamut. Definitely working on *Deal or No Deal* was a learning experience, and it helped me to understand what I would rather be doing. So if that's a way for me to gloss over that subject, then I will happily shift gears into something else."

More brief appearances in television shows and films, including *Get Him to the Greek*, *Remember Me*, *Cuts* and *Love, Inc.*, ensued, until July 2011 when she had her major breakthrough in the role of Rachel Zane in *Suits*. It was to make her name. Rachel was a paralegal at the legal firm Pearson Hardman, and becomes the love interest of Mike Ross (Patrick J. Adams), which again sent the media into a frenzy when the news about her Royal boyfriend emerged. There were plenty of shots when a scantily clad Meghan was pictured in a clench with her on-screen love interest, which often appeared when anything about Harry and Meghan came out. *Suits* was filmed in Toronto, although it was set in New York, and so Meghan upped sticks to the Canadian city, which is where she was to make her home for the best part of seven years.

The character of Rachel was, in part, based on Meghan: for example, the two of them are both foodies, interested in both cooking and eating, and visiting restaurants. This was one of the many reasons that Meghan, like a number of other Hollywood actresses (most famously Gwyneth Paltrow) set up her lifestyle website, which she called The Tig: the name derived from her favourite Italian wine, Tignanello. It was, said Meghan, a "hub for the discerning palate – those with a hunger for food, travel, fashion & beauty". This gave an insight into Meghan's life as curiosity in her grew: she shared details of favourite vacation reads (Michael Ondaatje's *The English Patient*), sustainable travel, famous acquaintances (Michael Bublé), playlists, favourite food and much, much more. The blog ran for three years until Meghan shut it down – another clear hint that she was soon to be entering into a lifestyle that it would be unwise to share online.

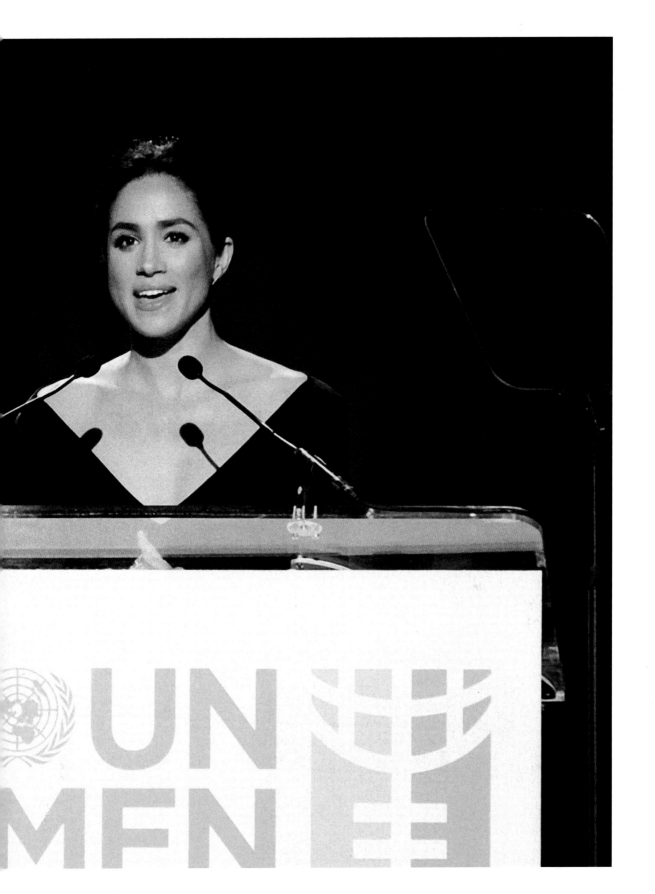

It was early on in the success of *Suits* that Meghan entered into her first brief marriage, to Trevor Engelson. Trevor (who bears a passing resemblance to Harry) was a film producer, born on 23 October 1976 in New York. His best-known film, in which Meghan appeared, is the Robert Pattinson vehicle *Remember Me*. The couple first met in 2004 and, after six years of dating, got engaged in 2010. They eventually tied the knot at the Jamaica Inn in Ocho Rios, Jamaica, in the course of a four-day affair with 102 guests. The wedding would be nothing like her second wedding; in some ways it resembled nothing more than a casual beach party. However, the marriage only lasted two years. Trevor had remained

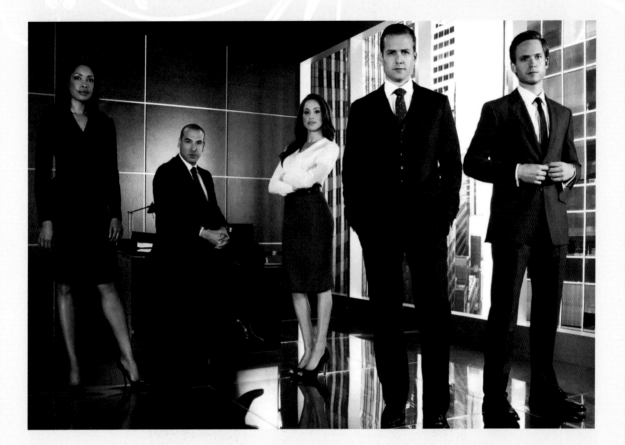

in LA while Meghan moved to Toronto and the long-distance aspect of their marriage was said to be a problem, to say nothing of Meghan's growing success. The divorce cited "irreconcilable differences"; the marriage was done.

Meghan was not lacking in admirers and her next boyfriend was Cory Vitiello, a well-known Canadian chef who ran one of the best-known restaurants in Toronto, The Harbord Room. They were an item between 2014 and 2016, and rumours persist that they were still an item when Harry and Meghan first met, although no one involved was keen to comment. At any rate, Cory soon found himself a single man once more.

It was during her involvement with *Suits* that Meghan found she had a global profile that she could put to good use – much as Harry's mother, Diana, had done a couple of decades earlier. She became a counsellor for the international charity One Young World, and spoke at the 2014 annual summit on the subjects of

ABOVE:

Meghan made her name in the television show Suits, *set in a New York law firm. She is pictured with co-stars, from left to right, Gina Torres, Rick Hoffman, Gabriel Macht and Patrick J. Adams, who plays her love interest in the show.*

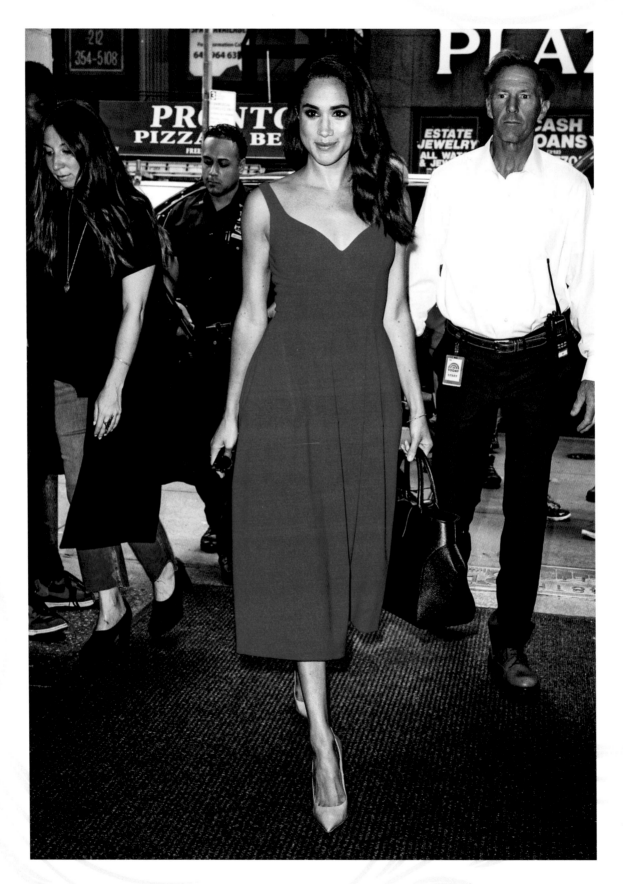

gender equality and slavery in the modern day. That same year, she also went to Afghanistan and Spain as part of the USO Chairman of the Joint Chiefs of Staff Holiday Tour. Two years after that, she became a global ambassador for World Vision Canada, in which role she visited Rwanda for the Clean Water Campaign, as well as taking a trip to India to raise awareness on the subject of issues about women. On top of that, she has carried out work with the United Nations Entity for Gender Equality and the Empowerment of Women. All of this must have had a tremendous impact on Harry, who is both extensively involved in his own charitable work and grew up with a mother who did exactly the same. It was also a good omen for her future with the Royal Family, in which charitable work and duty play a huge part.

So that is Meghan Markle, a thoroughly modern Royal bride with a background that has never been seen in the Royal Family before. Perhaps most crucial of all, however, given the pressures she is having to face, is her personality. Warm, relaxed and easy going, albeit with a serious side, Meghan has the ability to put those around her at ease. As an actress of many years' standing, she also has the ability to cope with the spotlight in a way that Harry's earlier girlfriends found difficult. And now, of course, just as she had established herself as a successful actress and charity worker, was going to come the meeting that would change her life.

OPPOSITE:

A super-stylish Meghan on her way to The Today Show *taping at New York's Rockfeller Center in July 2016. She and Harry were already dating by then.*

BELOW:

As Rachel Zane in Suits.

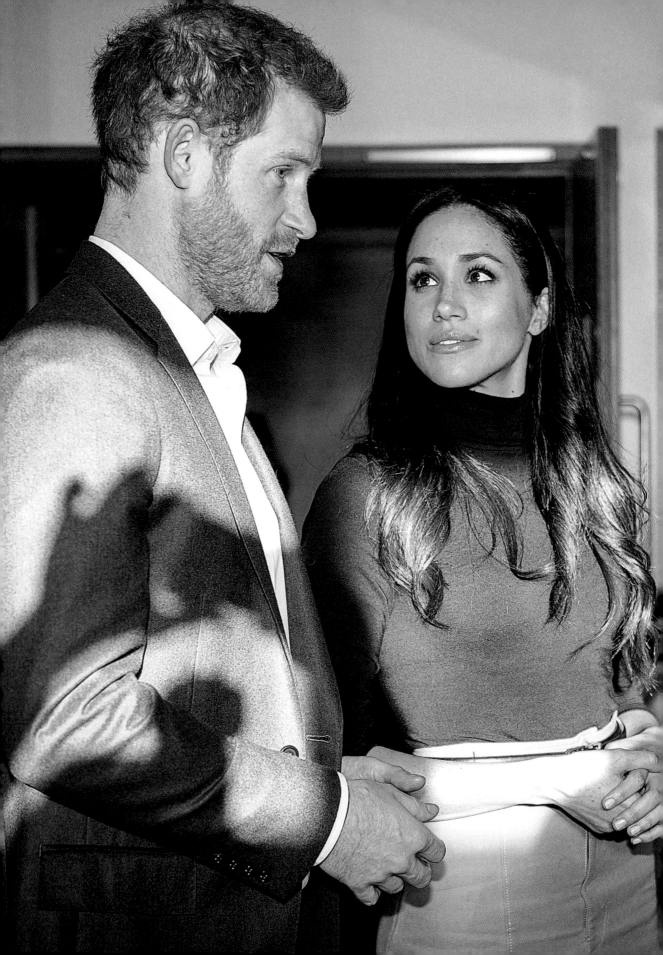

CHAPTER 3

A PERFECT MATCH

"THE FACT THAT I FELL IN LOVE WITH MEGHAN SO
INCREDIBLY QUICKLY WAS CONFIRMATION TO ME THAT
ALL THE STARS HAVE ALIGNED AND EVERYTHING
WAS JUST PERFECT."

PRINCE HARRY, NOVEMBER 2017

As more information began to emerge about Meghan and Harry's circle, in which people were integrating themselves from both sides of the Atlantic, more key figures began to emerge. There was in particular intensive speculation about who had brought the two of them together, albeit it some of it contradictory. For a start, just who had been their matchmaker? One obvious candidate was Misha Nonoo, a New York-based fashion designer who was born in Bahrain to an Iraqi father and English mother. She grew up in Chelsea and attended the ACS International School in Surrey and the Ecole Supérieure du Commerce Extérieur in Paris. More to the point, she is also one of Meghan Markle's closest friends and, indeed, designed the "Husband" shirt Meghan was wearing when the couple made their first joint appearance at the Invictus Games in September 2017. "We were seated next to one another at a lunch and we got along like a house on fire," Misha told the *London Evening Standard* of the time she and Meghan first met. "She has the most remarkable and generous spirit. I aspire to be as philanthropic as she is, and to have as much of an impact as her."

The friendship might never have been commented on were it not for one fact – Misha seems to have played a crucial role in bringing Harry and Meghan together. Misha is now divorced, but she, too, was married, to the Old Etonian Alexander Gilkes, who was co-founder of auctioneers Paddle 8 (where Harry's cousin, Princess Eugenie, briefly worked) and also, crucially, a close friend of Harry's. Misha met her husband-to-be when she was just 17 and a summer intern at Quintessentially, the concierge company. They married in 2012 and divorced five years later, which gave her yet more in common with Meghan – they were both young divorcees. They also had shared interests in spiritual issues, charity work and their love of animals.

Misha and Meghan's friendship just grew, with Instagram pictures showing the two of them on holiday in Ibiza and Formentera, rather sweetly captioned with the words, "When only children find sisters". (Meghan's half-siblings are much older than her.) It has never been confirmed that it was Misha who set Harry and Meghan up on a blind date together, and she, herself, will not talk about it but, given that she is Meghan's closest friend and was married to Harry's equivalent, it seems possible.

PREVIOUS PAGE:

During their visit to Nottingham, Harry and Meghan found time to attend Nottingham Academy. Bystanders were impressed by Meghan's natural style and the way she related to well-wishers.

OPPOSITE:

Meghan and her friend Misha Nonoo at the 12th annual CFDA/Vogue Fashion Fund Awards in 2015 in New York City. It is thought that Misha arranged the blind date on which the couple first met.

However, there has also been intensive speculation that the real matchmaker was Meghan Markle's friend Violet von Westenholz, daughter of former Olympic skier Baron Piers von Westenholz, a close friend of the Prince of Wales. She had known Harry for years – since childhood in fact, and her younger sister Victoria had even been romantically linked to him – and had met Meghan while doing some PR for Ralph Lauren.

"Harry was having a really hard time finding anyone," a source told E! Online. "It's hard enough finding someone new to date. He can hardly go on Tinder or a dating app like normal people, but to meet someone that you actually connect with, that was proving to be almost impossible. It was something he had confided in his closest friends about; he was ready to meet someone but it was so hard to actually find the right person. Meghan had been a part of the London social scene for a while and had slotted into the high society set really easily. And so when Harry told Violet he was

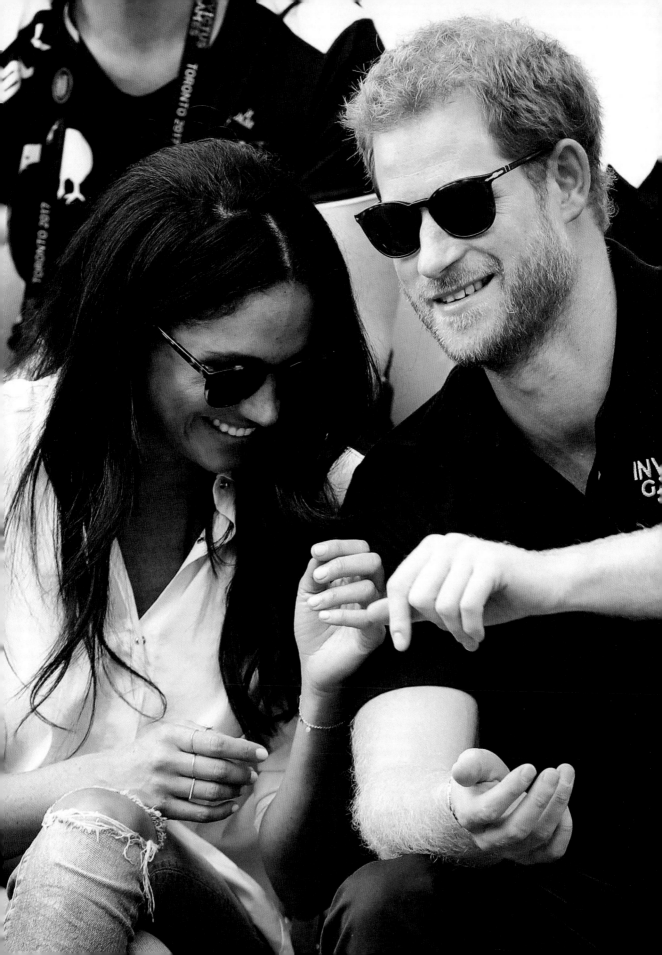

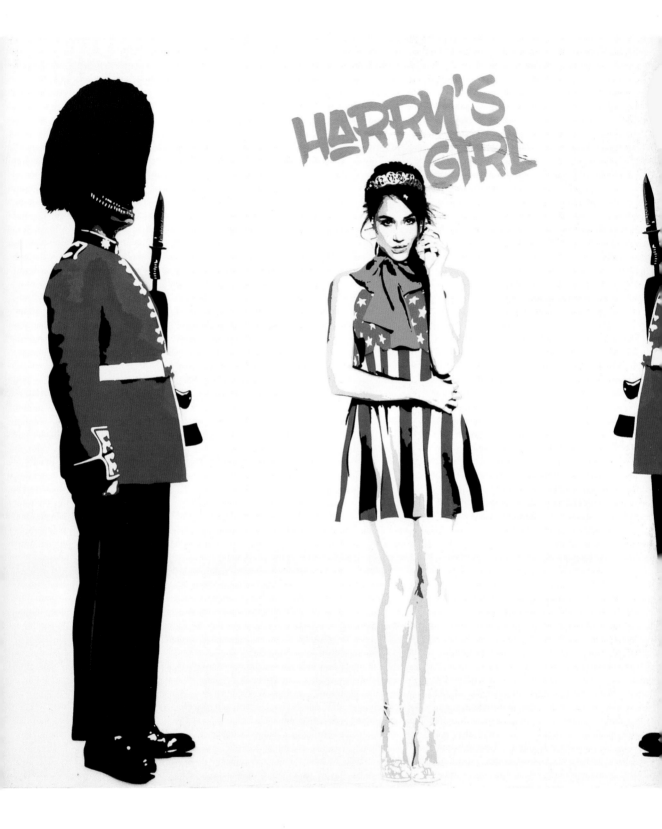

having trouble finding someone, Violet said she might just have the perfect girl for him."

Whoever was responsible, it was on a blind date that Harry and Meghan finally met, with neither knowing a great deal about the other from the outset, which they revealed after the engagement was announced, without naming their Cupid ("We should protect her privacy and not reveal too much of that," Meghan said.) There had been a great deal of speculation that the couple had met via the Invictus Games, but it emerged that it was good, old-fashioned matchmaking that brought the two together. And neither knew exactly what to expect.

For a start, Meghan was totally new to all things Royal, and took it remarkably in her stride when told that her blind date was actually a prince, although the way it was put to her seemed more to be a case of meeting someone she might like. However, romance was clearly on the cards. "It was definitely a set-up. It was a blind date for sure. We talk about it now. Because I'm from the States, you don't grow up with the same understanding of the Royal Family," Meghan said in the couple's joint television interview after the engagement was announced. But she had been taken aback to realize quite how much interest this new relationship would provoke. She might have been used to television stardom, but the aura surrounding the Royal Family was in another league altogether. "And so, while I now understand very clearly there is a global interest there, I didn't know much about him and so the only thing that I had asked her when she said she wanted to set us up was, I have one question: 'Well, is he nice?' Because if he wasn't kind, it just didn't seem like it would make sense."

LEFT:

*She's made her mark.
In late 2016 a piece of
street art appeared in north
London. Artist Pegasus
depicted Meghan wearing
a dress based on the US
flag, flanked by soldiers
of the Queen's Guard.*

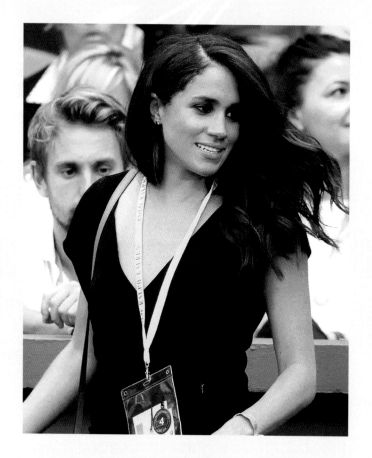

Nor did Harry know much about Meghan in return, contrary
to speculation that he'd previously seen her on television and had
voiced a desire to meet her. "I'd never even heard of her until this
friend said 'Meghan Markle' – I was, like, 'Right, OK, give me a
bit of background.' I'd never watched any of *Suits*," he admitted.
"I was beautifully surprised when I walked into that room and saw
her sitting there. I was, like, wow, I really have done well, I've got
to up my game, sit down and make sure I have good chat."

He did. The date clearly went extremely well and, if anyone
was star-struck, it was Harry, not Meghan, who is a woman who
can take pretty much anything in her stride. One Royal observer
noted that she was "funny, feisty, confident and she wasn't
swayed or knocked by the fact he was Prince Harry. She thought
he was terribly cute." Harry was very impressed to hear about
Meghan's charity work in Rwanda, and started bombarding her
with texts until he could get her to agree to meet again. "And
then it was, like, right, diaries," Harry continued. "We need to
get the diaries out and find out how we're going to make this

work, because I was off to Africa for a month, she was working. And we just said, 'Right, where's the gap?' And the gap happened to be in the perfect place."

Given the identity of the people involved, and the fact that the two lived on opposite sides of the Atlantic, they were clearly going to have to decide early on whether this had the potential to be serious and whether they wanted to give it a go. They did. "We met once and then twice, two dates back to back in London, last July," Harry said in their joint interview. "Then it was about three, maybe four weeks later that I managed to persuade her to come and join me in Botswana, and we camped out with each other under the stars for five days. Then we were really by ourselves, which was crucial to me to make sure we had a chance to get to know each other." This was a crucial test: Harry had a long-standing love of Africa (as did his brother, William, who proposed to Kate in Kenya) and, if the two of them could bond there, there was clearly a good prognosis for the future. It was also a place where there was utter privacy, no concerns about diners in nearby restaurants taking pictures of them, just a stark and beautiful landscape where they could get to know one another well.

And both were in the market for something more serious. Both were in their thirties, with Meghan two years older than Harry, and there was none of the coyness there might have been if they had been much younger at the time. In some ways, it was fortunate for everyone concerned that the relationship was so obviously serious so quickly, simply because, given the effort the two of them were going to have to make, they both had to know

BELOW:

The couple are seen swapping a quick embrace following polo at Cowarth Park in May 2017.

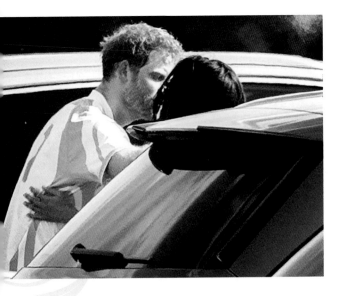

there was an actual point in doing so. "The fact that I fell in love with Meghan so incredibly quickly was confirmation to me that all the stars have aligned and everything was just perfect," Harry said in their joint interview. "This beautiful woman just tripped and fell into my life. We're a fantastic team, we know we are and,

over time, we hope to have as much impact as possible."

From that early meeting and the time in Botswana, the couple managed to meet every two weeks, keeping it as low key as possible. "Just to take the time to be able to go on long country walks and just talk," said Meghan, who said that the courtship had not felt like a whirlwind. "I think we were able to really have so much time just to connect, and we never went longer than two weeks without seeing each other, even though we were obviously doing a long-distance relationship. So we made it work."

In the world of the smartphone, they had to stay as private as possible, too – there were "cosy nights in in front of the television, cooking dinner in our little cottage," said Prince Harry. "It's made us a hell of a lot closer in a short space of time.

For us, it's an opportunity for really getting to know each other without people looking or trying to take photos on their phones."

William and Kate lived nearby, so it was easy to make off-the-radar introductions without the wider world noticing: "William was longing to meet her and so was Catherine, so, you know, being our neighbours, we managed to get that in quite a few times now," said Harry. "Catherine has been absolutely amazing, as has William as well, you know, fantastic support." Of course, his brother and sister-in-law were as aware as Harry of the difficulties of Royal dating, for the wider public would have been desperate for more information as soon as they knew something was going on.

In retrospect, there were signs that something really was going on. Meghan was seen in the Royal Box at Wimbledon that summer, although no one made the connection at the time. Indeed, no one was really sure who Meghan was: although *Suits* was shown in the UK – first on Dave and later via Netflix – she still was an unknown quantity for most of the British public, which suited Harry just fine. Both his previous serious girlfriends had been scared off by media attention and, although Meghan might have been able to cope with it in her own right, Harry did not want to expose her to it just yet.

There was also the minor matter of introducing her to his grandmother, the Queen. While this might not have been an important element in most relationships, in this particular one it was crucial, not least because Harry was going to have to ask his grandmother's permission to marry. Meghan proved herself to be just as unfazed about this as she was about everything else.

"It's incredible to be able to meet her through his lens: not just with his honour and respect for her as the monarch, but the love that he has for her as his grandmother," Meghan said. "All of those layers have been so important for me so that, when I met her, I had such a deep understanding and, of course, incredible respect for being able to have that time with her. She's an incredible woman."

And it didn't hurt that Meghan, like the Royals, was an animal lover, with a particular affection for dogs. "And the corgis took to you straight away," Harry added. "I've spent the last thirty-three years being barked at; this one walks in, absolutely nothing. Just wagging tails and I was just, like, 'argh'. The family together have been absolutely a solid support. My grandparents, as well,

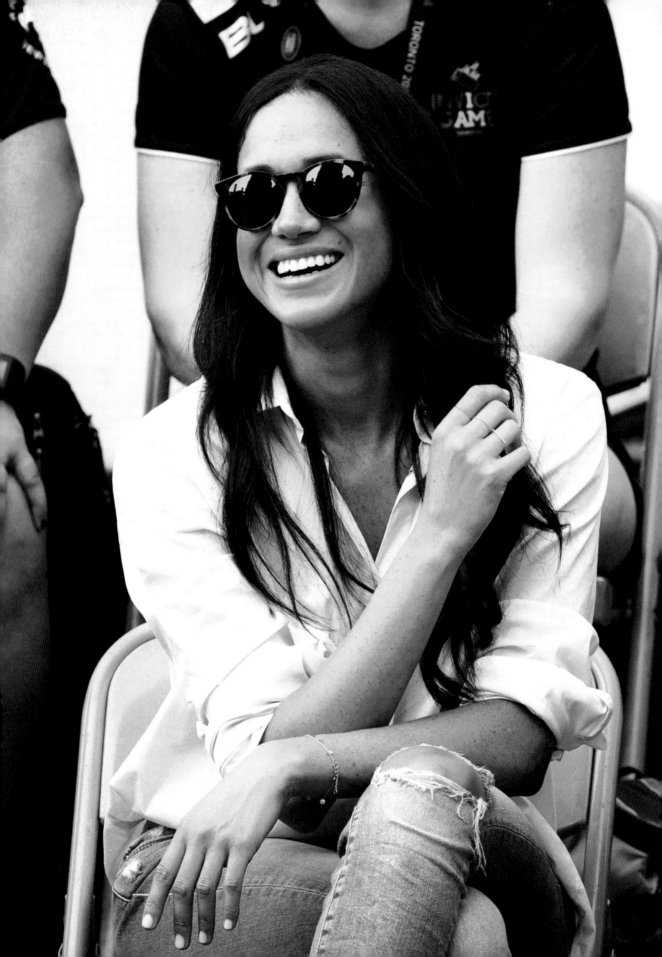

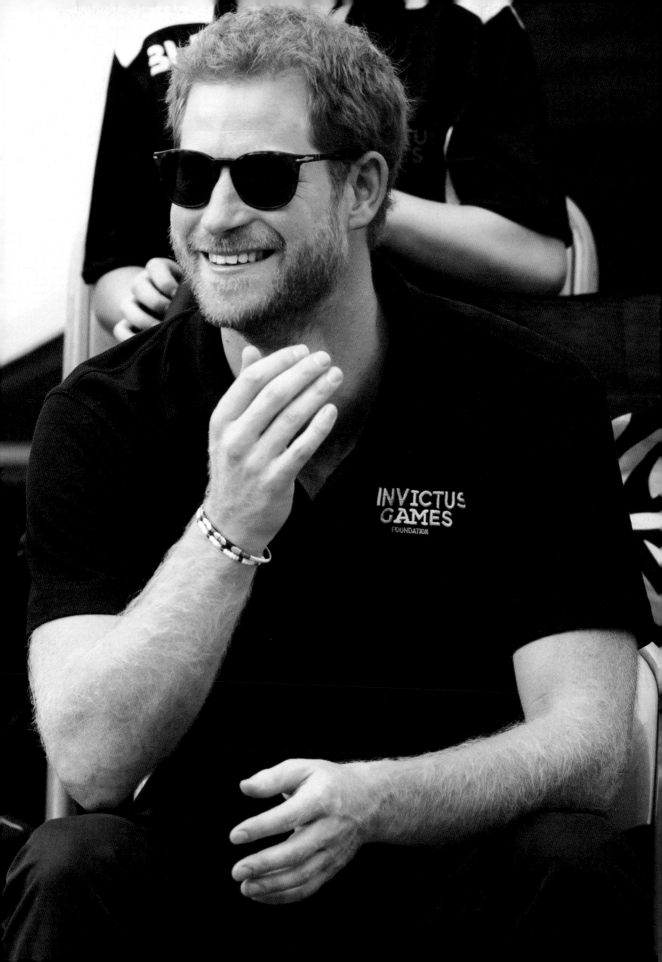

have been wonderful throughout this whole process, and they've known for quite some time. So how they haven't told anybody is, again, a miracle in itself. But now the whole family have come together and have been a huge amount of support."

That first date had clearly been a momentous one and the whole Royal romance did manage to stay under the radar for months, until Harry, who had spoken publicly of his pain at not being able to protect his own mother from the interests of the world outside, finally lashed out in an extraordinary and unprecedented statement, of which more anon. But for anyone in the know, the hints just grew bigger and bigger, and nor was the entire courtship just cosy evenings in at Nottingham Cottage (Nott Cott), Harry's Kensington Palace home.

Harry and Meghan met in the spring of 2016; as they later confessed, much of their courtship went on away from public glare, at least to begin with. "We were very quietly dating for about six months before it became news, and I was working during that whole time, and the only thing that changed was people's perception," Meghan told *Vanity Fair*. "Nothing about me changed. I'm still the same person that I am, and I've never defined myself by my relationship."

At around that time, a series of images began to appear on Meghan's Instagram account that, in retrospect, are highly revealing. First, there was a picture of Meghan with a bunch of flowers and the caption, "Swooning over these. #London #peonies #spoiledrotten". There followed a love heart with "Kiss me" stamped on it, captioned, "Lovehearts in #London". This was followed by a couple of matches in a heart shape, a card bearing the motto "The foolish wait" (as if), more peonies and, finally, a game changer, of which more below.

But any couple happy and in love wants to share the news with the rest of the world, and so, gradually – perhaps even subconsciously on their part – hints began to emerge that something was afoot. In the UK, the *Sunday Express* announced that the pair were an item and that Harry was happier than he had been in years. Coincidentally, or not, perhaps, Meghan posted a picture on her Instagram account of two bananas snuggling up together with the words, "Sleep tight". And from that moment, global curiosity levels shot sky high – and there they stayed.

At first, no one knew quite what to make of it. Not only was

PREVIOUS PAGE:

Harry and Meghan evidently enjoying each other's company as they watch a wheelchair tennis match during the Invictus Games 2017.

OPPOSITE:

Prince Harry is pictured attending a StreetGames "Fit and Fed" holiday activity session in Central Park, East Ham, in July 2017. On the other side of the Atlantic, Meghan was spotted wearing a very similar bracelet.

this a first in every conceivable way possible, but was it serious? Or was it a fling? Some members of William and Harry's circle had been a little sniffy about Kate Middleton – how would they react to Meghan? Politely and warmly, if they had any sense, because there quickly came another indication that this was something serious – it was reported in *People* magazine that Meghan had already met Prince Charles. "Harry is pretty serious about her and she is pretty serious about him," said a source. "It's great. They have a lot in common and I'm sure they will get on very well."

That was enough to spark a feeding frenzy. Suddenly, everyone – but everyone – wanted to know more about Meghan and, when it emerged that she was a biracial divorced actress, interest soared to an all-time high. In yet another totally unprecedented move, Harry issued a strongly worded statement asking everyone to back off and give the couple a little space.

"Since he was young, Prince Harry has been very aware of the warmth that has been extended to him by members of the public," it read. "He feels lucky to have so many people supporting him and knows what a fortunate and privileged life he leads. He is also aware that there is significant curiosity about his private life. He has never been comfortable with this, but he has tried to develop a thick skin about the level of media interest that comes with it. He has rarely taken formal action on the very regular publication of fictional stories that are written about him and he has worked hard to develop a professional relationship with the media focused on his work and the issues he cares about.

"But the past week has seen a line crossed. His girlfriend, Meghan Markle, has been subject to a wave of abuse and harassment. Some of it has been hidden from the public – the nightly legal battles to keep defamatory stories out of papers; her mother having to struggle past photographers in order to get to her front door; the attempts of reporters and photographers to gain illegal entry to her home and the calls to police that followed; the substantial bribes offered by papers to her ex-boyfriend; the bombardment of nearly every friend, co-worker and loved one in her life. It is not right, that a few months into a relationship with him that Ms Markle should be subjected to such a storm. He knows commentators will say this is 'the price she has to pay' and that 'this is all part of the game'. He strongly disagrees. This is not a game – it is her life and his."

Amid speculation that William might have thought this unwise, another Royal statement was issued to the *Daily Telegraph*: "The Duke of Cambridge absolutely understands the situation concerning privacy and supports the need for Prince Harry to support those closest to him." It was clear: they were all singing from the same hymn sheet.

It worked – to an extent – but at the same time, it had the possibly unanticipated effect of actually confirming the relationship. Until then, no one had been sure how seriously to take the rumours – now it was not only clear that it was all true, but that the relationship was serious, as well. And that subconscious desire to proclaim their relationship to the world was also still clear – they were spotted wearing matching bracelets on either side of the Atlantic.

Interest in Meghan remained as strong as ever, although the edge was taken off the aggressiveness with which some people were attempting to find out more about her, and, in some ways, the publication of that statement seemed to take the pressure off the two of them. Neither seemed quite so worried about keeping it a secret: in December, Harry went on an official trip to Barbados, but rather than coming straight back to London as had originally been planned, he made an unofficial stopover in Toronto. Around that time, Meghan was spotted wearing a necklace with the initials "M" and "H".

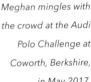

BELOW:

Meghan mingles with the crowd at the Audi Polo Challenge at Coworth, Berkshire, in May 2017.

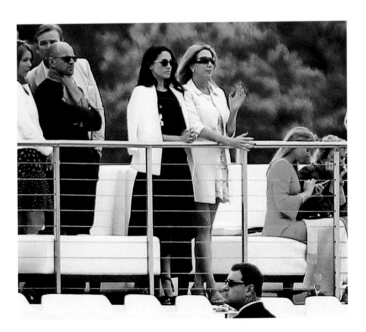

The couple were sticking to their resolve of not being apart for more than two weeks: in mid-December, the two of them were seen in London's West End, wearing beanie hats to protect against the cold, walking hand in hand through the throng. They took in a performance of *The Curious Incident of the Dog in the Night-Time* and, elsewhere, were seen buying a Christmas tree. Meghan may not have graduated to Christmas-at-Sandringham status yet, but they were clearly happy in their domestic life together, although that year they were to spend Christmas apart.

As 2017 began, Meghan was becoming quite a regular, albeit unofficial, visitor to the UK's capital. Early in the year, the couple were spotted again, having dinner at London's trendy Soho House, and then in March, another indication that the relationship was really serious came through. One of Harry's best friends, Tom "Skippy" Inskip was getting married to software developer Lara Hughes-Young in Montego Bay, Jamaica (about 60 miles from where Meghan first got married), and Harry was one of the ushers.

He took Meghan to the wedding with him – another clear indication that she was a permanent fixture in his life – and the duo stayed at the chic Round Hill Resort, which, at £5,000 a night, showed Harry certainly knew how to treat the woman in his life. Indeed, JFK and Jackie Kennedy had gone there for their honeymoon. Harry's aunt, Sarah, Duchess of York, and her daughter, Eugenie, were also in attendance, allowing Meghan to get used to moving in Windsor circles while still in an unofficial and relaxed ambience. The whole occasion was, in fact, an enormous success, even when Harry sent a waitress and a tray of drinks flying when he tried to do Michael Jackson's moonwalk. That prompted much hilarity, but it was noticeable to everyone how close the couple were by now. Totally at ease in each other's company, it was now becoming inconceivable that there wouldn't be an engagement announcement soon.

A princess (or duchess) cannot be seen to promote anything, however, and so it was in April that year that Meghan quietly and without fanfare closed down her blog, The Tig. There was intense speculation that she had been advised to do this by the Palace, although that was not confirmed. Shortly afterwards, Meghan was seen cheering Harry on at the polo, and then it was another high-profile wedding – that of Pippa Middleton, Harry's

OPPOSITE:

Brothers in arms. Princes William and Harry attend the wedding of the Duchess of Cambridge's sister Pippa Middleton to James Matthews at St Mark's Church, Englefield Green in May 2017. Meghan attended the evening reception.

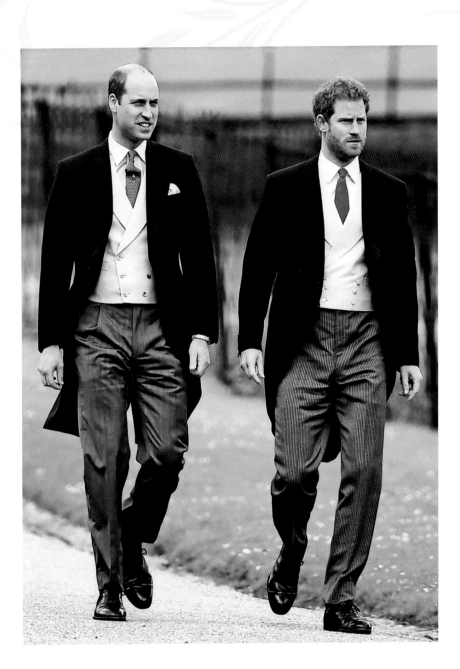

sister-in-law, to financier James Matthews in the Berkshire village of Bucklebury, where the Middletons lived. Everyone had to play it carefully here. There were already concerns that Pippa would be eclipsed by the appearance of her sister Kate, and Meghan's presence raised the risk even more. In the event, Meghan kept a very low profile; she didn't attend the actual ceremony and, instead, turned up at the evening reception, after Harry had driven off to collect her.

"[Harry] knew this was all about Pippa's big day and he and Meghan jointly decided they didn't want to upstage her," a source told the *Sun*. "Harry went all the way back to London to get Meghan and bring her to the party. He was determined not to upstage Pippa but also really wanted them to enjoy the wedding together. He didn't want Meghan having to arrive alone, without

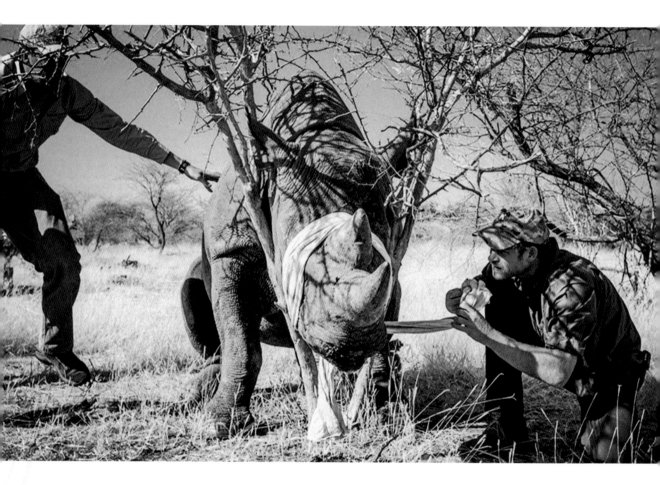

him alongside her, at the reception." And given that this was their second wedding together in a matter of months, it was once again clear that the two were both in sync and serious about one another. Meghan was to reveal as much very soon.

But before she did so, Harry whisked her off on holiday to Africa to celebrate her 36th birthday. It was back to Botswana

(this time at £650 a night) to the Meno a Kwena camp, where they stayed in a luxurious tent overlooking the Boleti River. Botswana, which Harry has described as his "second home", is where they had first bonded just over a year previously; now they were staying in the height of luxury. Their tent – one of just nine at the resort – was furnished with a king-sized bed, open-air shower and traditional wooden carved furniture; it overlooked a stretch of the river where elephants and zebras came out to drink.

Back home again, an interview with Meghan was published in *Vanity Fair* that gave the clearest indication to date that the couple were to wed, a very unusual move for someone who was about to marry a senior member of the Royal family. It made global headlines because of a small quote from Meghan, which was actually in the context of a much longer interview that was really about her life, not her relationship with Harry. But perhaps no one should have been surprised by the intense interest she aroused.

"We're a couple," she said. "We're in love. I'm sure there will be a time when we will have to come forward and present ourselves and have stories to tell, but I hope what people will understand is that this is our time. This is for us. It's part of what makes it so special, that it's just ours. But we're happy. Personally, I love a great love story."

Of course, Meghan would never have spoken so openly were she not at liberty to do so and, given her words, it was clear that a major announcement was in the air. But there were still a few more months to go before Harry and Meghan were to make it official, still a little while even before they were to make their first official appearance together, although it was pretty clear to everyone that this was a very modern Royal romance, more so even than that of William and Catherine. It was to be a case of Californian sunshine beaming into the heart of the Windsors. The nation was on tenterhooks. With an unstable political situation both within the UK and also out in the wider world, the nation was in need of a good Royal love story. And in the story of Harry and Meghan, so unusual and yet so in keeping with the new modern Britain, that is exactly what they were going to get.

OPPOSITE:

In January 2017, it was announced that Harry would be Patron of Rhino Conservation Botswana (RCB). This picture was taken the previous September, when he joined an RCB operation to fit tracking devices to rhinos.

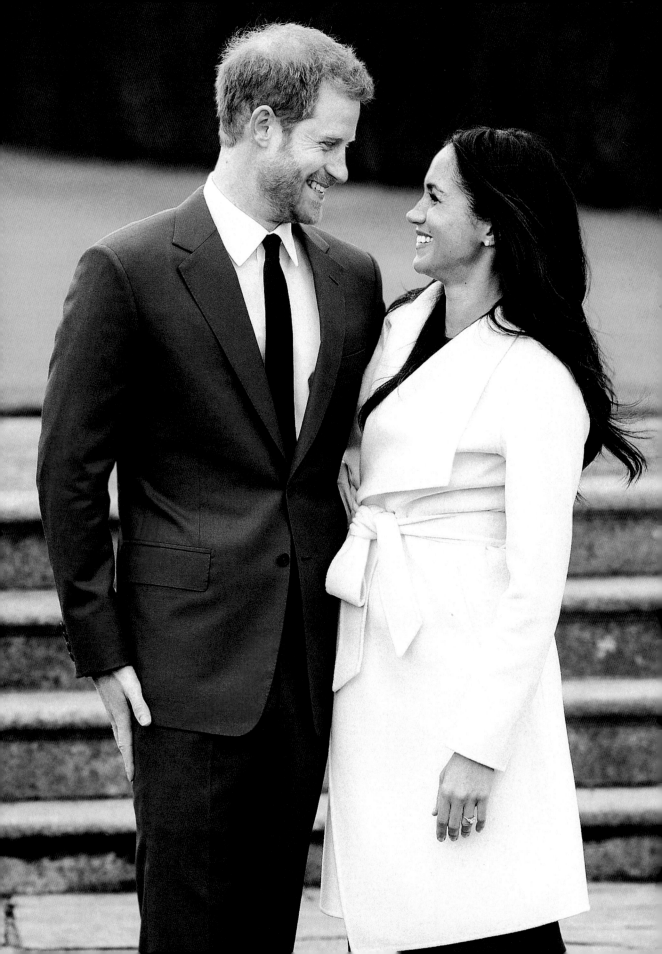

CHAPTER 4

A ROYAL
ENGAGEMENT

"PERSONALLY, I LOVE A GREAT LOVE STORY."

MEGHAN MARKLE, SEPTEMBER 2017

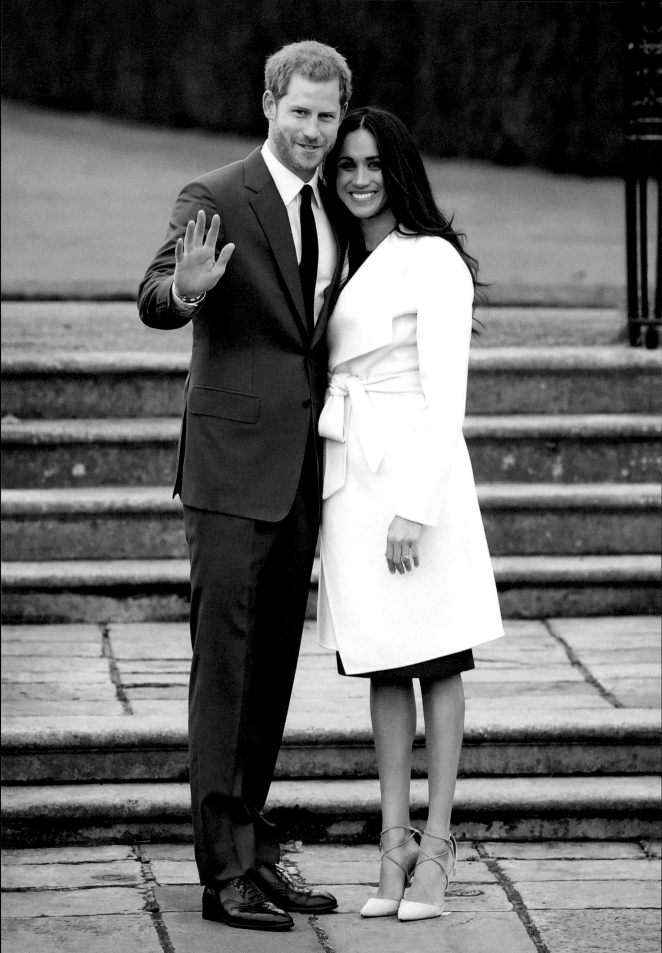

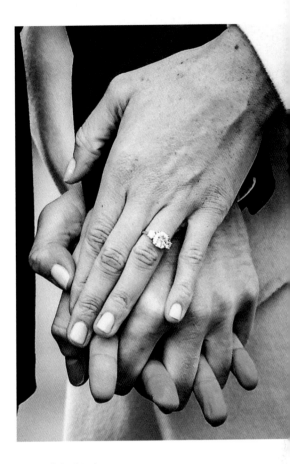

November 2017, and a cosy night in for the happy couple at Nott Cott. Harry had been a dab hand at cooking since his Eton days and Meghan was a self-acknowledged foodie who had frequently posted recipes on her blog, so what could have been more natural than the two of them to be roasting a chicken together? Or "trying to roast a chicken", as Harry later said.

Harry's mind might, indeed, not have been on the task in hand, for a much bigger preoccupation was looming. There was no doubt as to how serious his relationship with Meghan had become, and Harry had often spoken longingly of settling down, as his brother had done, into palpable domestic happiness with his wife and children. William had proposed in the wilds of Africa; would Harry do likewise? No: warm and happy in front of the kitchen stove, the moment to do it was now.

But Harry was a traditional sort of chap, and so he proposed in the traditional way. "It was so sweet and natural and very romantic. He got down on one knee," Meghan said later in the television interview the pair gave when the announcement of their engagement was made on 27 November. "As a matter of fact, I could barely let you finish proposing. I said, 'Can I say yes now?'"

Harry took over the story: "There was hugs, and I had the ring in my finger. I was, like, 'Can I give you the ring?' She goes, 'Oh, yes! The ring!'" And slowly the couple opened up about the relationship: Harry revealed that they had only been on a couple of dates together when he persuaded her to go away – and it was that that had sealed the deal. "I managed to persuade her to come and join me in Botswana," he said. "And we camped out with each other under the stars... she came and joined me for five days out there, which was absolutely fantastic." It was a proper chance for the two of them to get to know one another, he said, and decide that they were prepared to embark on a long-distance relationship. The gamble had clearly paid off.

OPPOSITE and
PREVIEW PAGE:

Prince Harry and Meghan Markle glow with happiness as they announce their engagement. While not totally unexpected, they still managed to take the nation by surprise.

ABOVE RIGHT:

Meghan shows off her engagement ring, which incorporated some diamonds from Princess Diana's personal collection. Harry designed the ring himself.

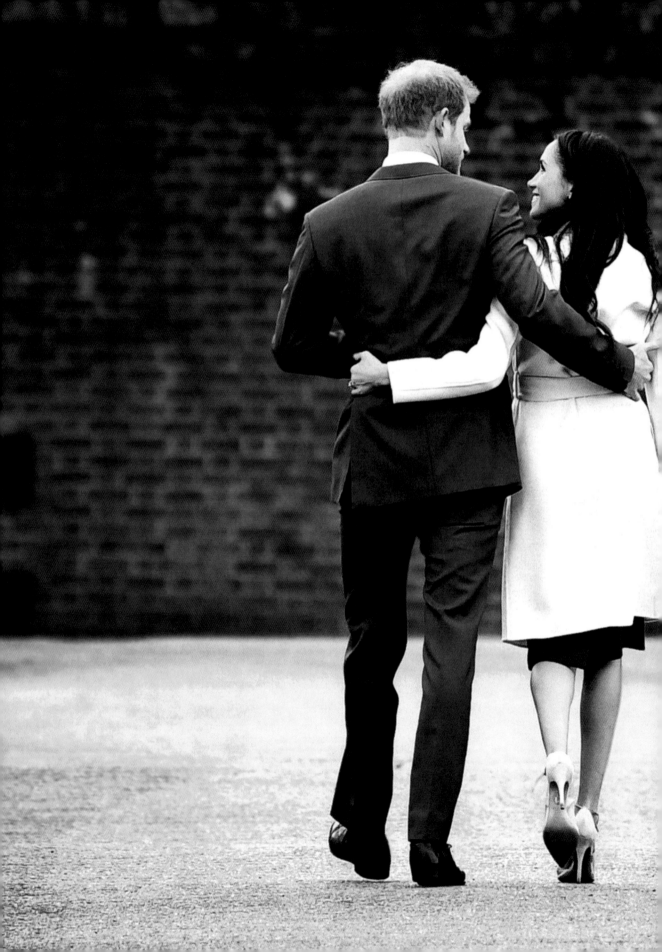

The actual announcement was made from Clarence House, home to Prince Charles. "His Royal Highness The Prince of Wales is delighted to announce the engagement of Prince Harry to Ms Meghan Markle," it read.

"The wedding will take place in Spring 2018. Further details about the wedding will be announced in due course. His Royal Highness and Ms Markle became engaged in London earlier in the month. Prince Harry has informed Her Majesty The Queen and other close members of his family. Prince Harry has also sought and received the blessing of Ms Markle's parents. The couple will live in Nottingham Cottage at Kensington Palace."

In the immediate aftermath of the announcement – and in time-honoured tradition – the pair appeared to answer a few questions and show off the ring. Somewhat poignantly, their first appearance as an engaged couple took place in the sunken garden in Kensington Palace, which is the site of the memorial garden created to commemorate the twentieth anniversary of Princess Diana's death. But whatever melancholy thoughts might have been in Harry's mind on its creation were clearly long gone; he and Meghan were beaming with happiness, Harry in a blue suit and tie, Meghan in a chic white overcoat and very high heels. When did

Harry know Meghan was The One? he was asked. "The very first time we met," Harry replied. Meghan said she was "so very happy, thank you". Harry added that he was "thrilled, over the moon". And, of course, Meghan was only too happy to show off her ring.

The engagement ring that William had given to Catherine was the one their mother had worn and now Harry was determined to refer to his mother in the ring he gave to Meghan, too. "The ring is obviously yellow gold because that's her [Meghan's] favourite and the main stone itself I sourced from Botswana and the little diamonds either side are from my mother's jewellery collection to make sure that she's with us on this crazy journey together," he said. "I think she would be over the moon, jumping up and down, you know, so excited for me, but then, as I said, would have probably been best friends with Meghan. It is days like today when I really miss having her around and miss being able to share the happy news."

Unsurprisingly, there was immediate and global worldwide interest in the announcement, with Meghan's long-term co-star on *Suits*, Patrick J. Adams, tweeting somewhat mischievously, "She said she was just going out to get some milk…" This was followed up by a rather more serious message, however: "Playing Meghan's television partner for the better part of a decade uniquely qualifies me to say this: Your Royal Highness, you are a lucky man and I know your long life together will be joyful, productive and hilarious. Meghan, so happy for you, friend. Much love."

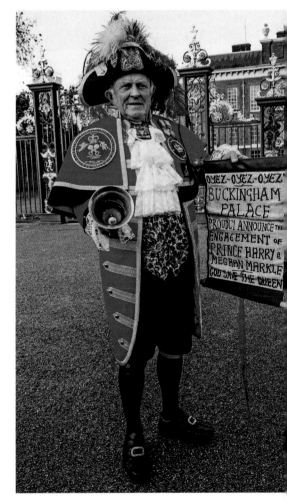

RIGHT:

The Town Crier, Tony Appleton, outside Kensington Palace, announcing the engagement of HRH Prince Harry and Ms Meghan Markle on 27 November 2017.

The Obamas also sent their congratulations, while – rather more pertinently – the rest of the Royal Family and Meghan's parents expressed their delight. Prince Charles was on a visit to the model town of Poundsbury that he had created in Dorset; he was "thrilled" and "very happy indeed", he said. It

was "very good" and he was "thrilled for them both. They'll be very happy indeed." The Duke and Duchess of Cambridge said, "We are very excited for Harry and Meghan. It has been wonderful getting to know Meghan and to see how happy she and Harry are together." And Meghan's own parents released a joint statement: "We are incredibly happy for Meghan and Harry. Our daughter has always been a kind and loving person. To see her union with Harry, who shares the same qualities, is a source of great joy for us as parents."

It was not long before further details about the wedding began to emerge. It was to be held in May 2018 at St George's Chapel, Windsor Castle, which is where Harry's uncle Prince Edward had married Sophie Rhys-Jones, and where his father and the Duchess of Cornwall had attended a service of prayer after their ceremony at the Windsor Guildhall. It was, in a way, a tactful choice: the other two alternatives – St Paul's Cathedral, which is where Harry's parents had married, and where his mother's funeral had taken place, and Westminster Abbey, which is where William and Catherine wed – were just too grand, not least as Meghan was, after all, a divorcee. Almost every rule in the Royal wedding book was being rewritten for Meghan and Harry, but one of those venues might have been thought to have been a step too far.

At any rate, Harry and Meghan, a Royal couple unlike any other, were clearly determined to do it their way. For a start,

BELOW:
Members of the media gather outside Kensington Palace on the day Clarence House announced the engagement of Prince Harry and Meghan Markle.

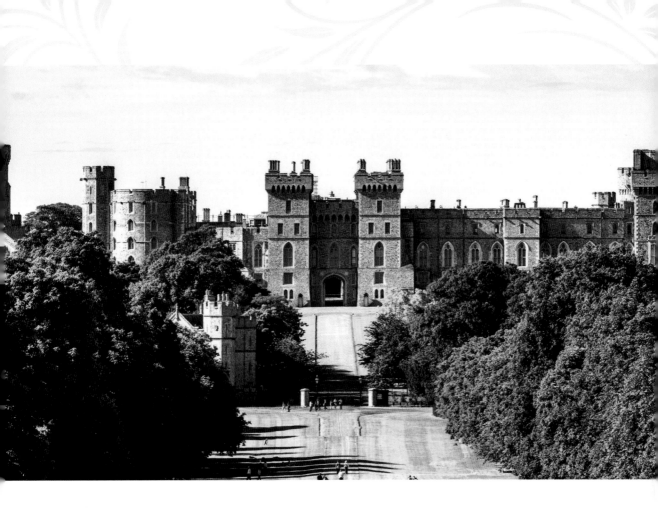

not many Royal grooms would have been engaged in cooking a chicken when the proposal took place; meanwhile, Meghan's New Age tastes were well known and there was speculation that the duo might have something slightly different planned. The couple were "leading the planning process for all aspects of the wedding", said their spokesman, Jason Knauf, adding that they were working on ideas that would allow the public to "feel part of the celebrations. This wedding, like all weddings, will be a moment of fun and joy that will reflect the characters of the bride and groom," he continued. Windsor was a "special place" for the couple, he said, and added that it was "an incredibly happy day" and that they were "overwhelmed by support from the UK and around the world".

But, of course, this remained a highly unusual situation for a member of the Royal Family to be in and there had clearly been a huge amount of work behind the scenes to resolve what had to be done. Because Meghan had attended a Catholic school, it was erroneously thought that she was, herself, a Catholic. She was, in fact, a

ABOVE:

Windsor Castle, viewed from the Long Walk. The wedding took place in May 2018 at St George's Chapel.

NEXT PAGE:

A media frenzy: the front pages of British newspapers following the announcement of the engagement.

73

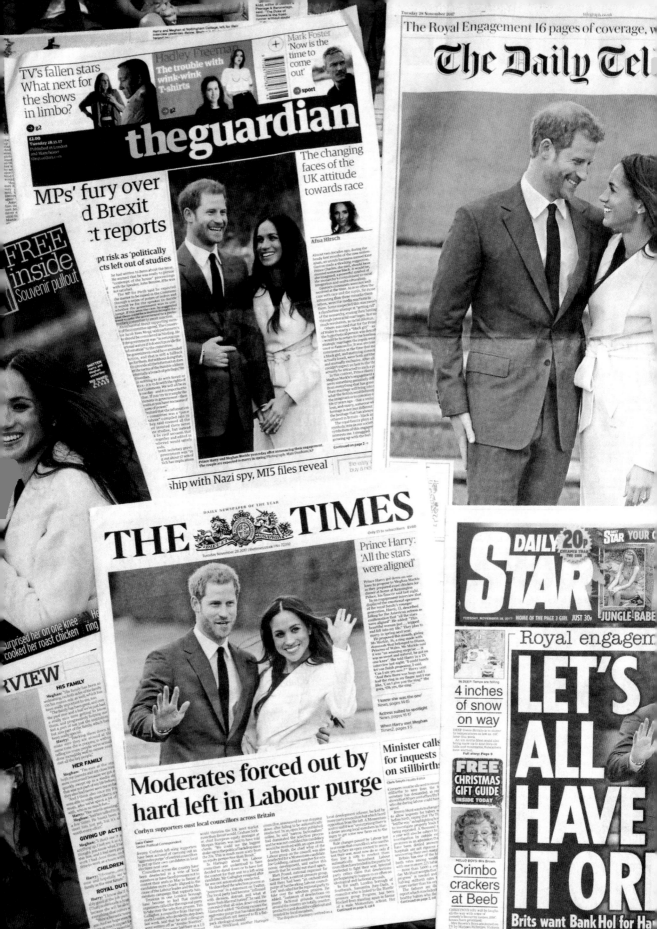

TV's fallen stars
What next for
the shows
in limbo?

Hadley Freeman
The trouble with
wink-wink
T-shirts

Mark Foster
'Now is the
time to
come
out'

sport

£2.00
Published in London
and Manchester
theguardian.com

Tuesday 28.11.17

theguardian

The changing
faces of the
UK attitude
towards race

Afua Hirsch

MPs' fury over
d Brexit
t reports

pt risk as 'politically
cts left out of studies

FREE
inside
Souvenir pullout

ship with Nazi spy, MI5 files reveal

Prince Harry and Meghan Markle yesterday after announcing their engagement. The couple are expected to marry in spring. Photograph: Matt Dunham/AP

Continued on page 2

Tuesday 28 November 2017

The Royal Engagement 16 pages of coverage, w

The Daily Tel

surprised her on one knee
cooked her roast chicken
He
ring,

RVIEW

HIS FAMILY

HER FAMILY

GIVING UP ACTIN

CHILDREN

ROYAL DUTI

DAILY NEWSPAPER OF THE YEAR

THE TIMES

Tuesday November 28, 2017 | thetimes.co.uk | No 72292

Only £5 to subscribers £1.60

Prince Harry:
'All the stars
were aligned'

'I never she was the one'
News, pages 14-15

Actress suited to spotlight
News, pages 16-17

When Harry met Meghan
Times2, pages 1-5

Moderates forced out by
hard left in Labour purge

Corbyn supporters oust local councillors across Britain

Lucy Fisher
Senior Political Correspondent

Minister calls
for inquests
on stillbirths

Royal engagem

IN DEEP: Temps are falling

**4 inches
of snow
on way**

Full story: Page 9

**FREE
CHRISTMAS
GIFT GUIDE**
INSIDE TODAY

HELLO BOYS: Mrs Brown

**Crimbo
crackers
at Beeb**

LET'S
ALL
HAVE
IT OR

Brits want Bank Hol for Ha

Continued on page 2, col

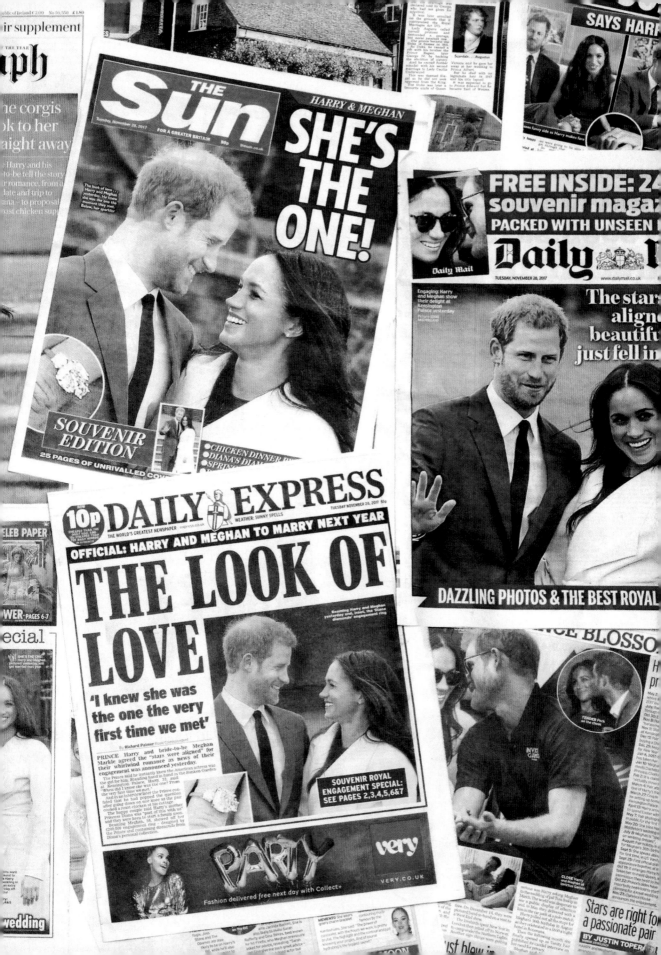

Protestant, but her grandmother-in-law-to-be was the Head of the Church of England, so it was announced that Meghan would be baptized into the Church as well and would also be confirmed before the wedding. Her future grandmother-in-law was also the Head of State (her father-in-law-to-be and brother-in-law-to-be would also one day inhabit that position), so it was also announced that Meghan would take British citizenship. An American marrying a Prince of the Royal blood was deemed quite acceptable these days, but she couldn't stay American, it seemed. Or would she adopt dual nationality? It was not yet clear.

Further details of their life together and, in particular, Meghan's new life began to emerge. It was then that it was widely reported that Meghan had two dogs (the interest she had in common with most of the Royal Family): one of them, Guy, would be joining her in the UK but the other, Bogart, would not. Meghan would be giving up some of her charity preoccupations, such as the work she did on gender with the United Nations, and, instead, would concentrate on the Royal Family's own work, becoming the fourth patron of the Royal Foundation of the Duke and Duchess of Cambridge and Prince Harry.

It was not long before Meghan got her first taste of what life as a Royal was to be. Just four days after the engagement was announced, she and Harry went on their first joint walkabout, to Nottingham, a place that Harry said has become "very special" to him (it was his eighth visit in five years). In their engagement interview, Meghan had said she was keen to get her "boots on the

LEFT:

In stylish matching coats, the couple meet the crowds of Nottingham during their first joint walkabout.

OVERLEAF:

Meghan's natural warmth and grace won over the excited crowds.

ground"; this was her first chance to do so and she carried it off magnificently.

Beaming and waving to the crowds, Meghan might not have come from the more typical background for a Royal princess but that certainly didn't seem to concern the many well-wishers who thronged their route. Radio Nottingham had prepared an enormous engagement card to be signed by the locals: "You've got to believe in the fairy tale. That's part of the excitement," said one of them, Kathryn Moran, a 25-year-old barrister. Meanwhile, the fact that Meghan was an American divorcee made her "more relatable", Abbie Goodband, an administrator at Boots the Chemist, said.

Irene Hardman, 81, had met Harry twice before. "I've got him a little goody bag," she said. "I've bought two fridge magnets with Nottingham on. I brought lots of information leaflets on surrounding places, such as Newstead Abbey and the castle.

I've bought him Haribo and some Nottingham fudge, and a Christmas card with Nottingham on, and also a card with 'Congratulations' on." She had met a good many of the other Royals over the years, including Diana, and, on Meghan, she was adamant: "She's just beautiful. I honestly think she's going to be the right one for him. If I get the chance, I will make sure I say, 'Look after Harry for us.'"

If this was to test the waters of the public's reaction to Meghan, it went staggeringly well. The weather was freezing but thousands turned out, waving both British and American flags. Many were carrying cards to be handed over, while Harry and Meghan looked like a couple of old pros as Harry took on one side of the street and Meghan the other. Harry, of course, had done this countless times before but, for Meghan, it was all new. That said, appearing in front of crowds and dealing with excited well-wishers, of course, went with the territory of being an actress, so she was not as overwhelmed as others in her position might have been.

The crowds could be heard chanting, "Harry, Harry" and "Meghan, Meghan"; Meghan gracefully accepted cards and flowers, saying, "Thank you so much," and, "I really appreciate that." She could have been born for the role. She was also seen giving Harry a reassuring pat on the back, just as she had been the encourager and the nurturer during their engagement interviews. The body language between them said it all.

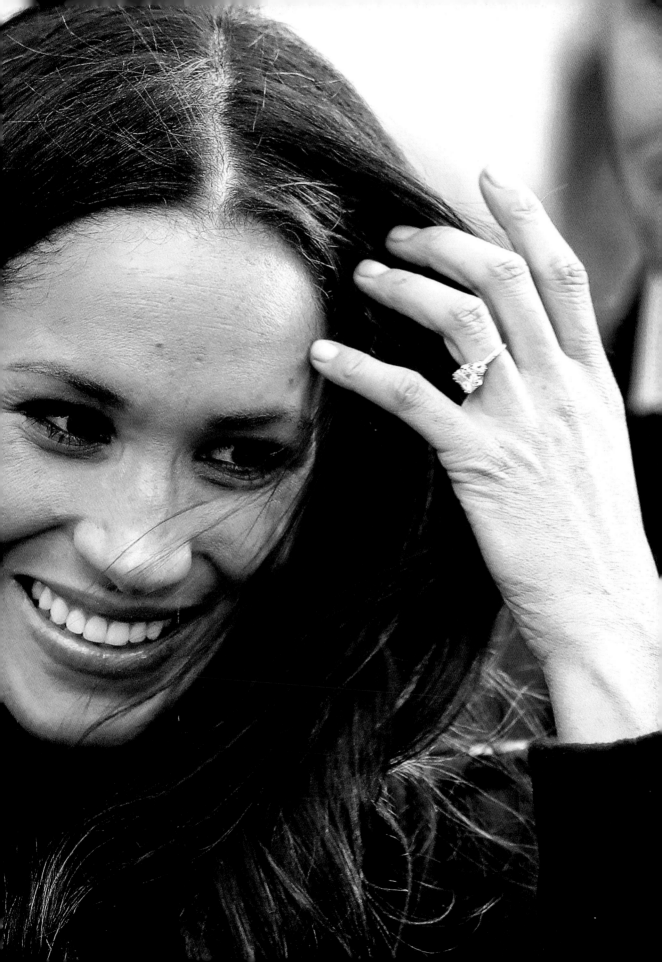

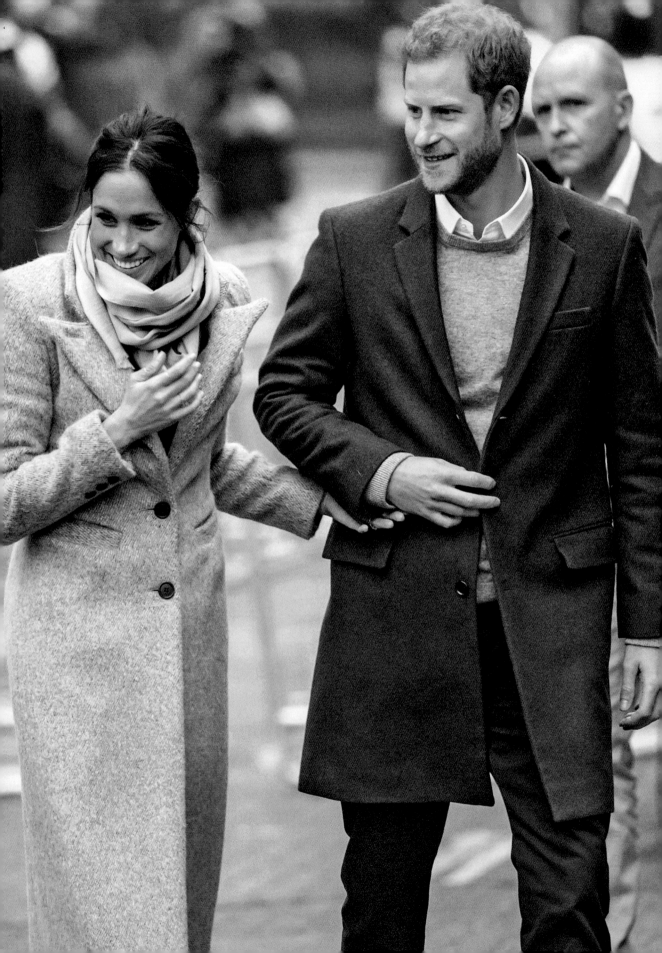

CHAPTER 5

CHANGING TIMES

"IT WAS JUST A CHOICE, RIGHT? I THINK THAT
VERY EARLY ON, WE REALIZED WE WERE GOING TO
COMMIT TO EACH OTHER."

MEGHAN MARKLE, NOVEMBER 2017

Prince Harry is very unlikely ever to become King but, in his choice of bride and his own lifestyle and concerns, he and Meghan represent the future of the Royal Family. One of the reasons that the monarchy has survived so long is its adaptability: Harry's ancestors changed their image time and again to reflect the society in which they lived. It was only in Queen Victoria's time that the concept of the "Royal Family" as such began to emerge, while it was just over 100 years ago, in 1917, that the family changed its name from Saxe-Coburg-Gotha to Windsor. It followed a proclamation by George V, who realized that the name was too German, not least as Britain was still fighting World War I.

So the advent of Meghan Markle could not have been more positive for the future of the monarchy. The face of Britain had changed enormously over the Queen's hugely long reign and it was important that the Royal Family reflect that. The process had begun with Princess Diana and, after her untimely death at the age of just 36 – the same age Meghan would be when she married

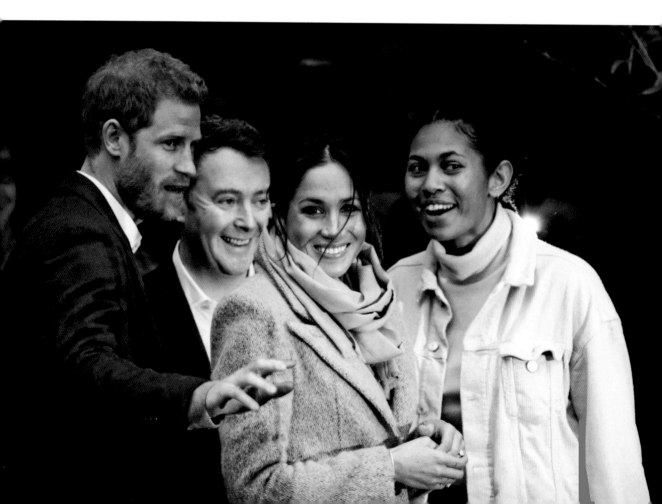

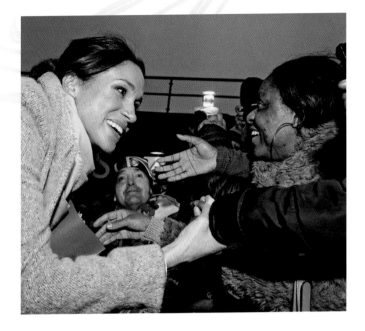

PAGE 80:

Harry and Meghan visit charity Reprezent in London in January 2018.

OPPOSITE:

Meeting the team at the Reprezent training programme, established in 2008 to fight knife crime.

ABOVE:

Meghan meets well-wishers as she and Harry leave after the visit to Reprezent. "Meghan mania" was going strong.

Harry – it was quite clearly carrying forward with her two sons. In the year leading up to the engagement announcement, William, Kate and Harry had been campaigning for better understanding of mental-health issues – a far cry from the "stiff upper lip" approach the Windsors had adopted in the past. Some of this was, undoubtedly, influenced by Meghan: a California girl in both background and outlet, she was no stranger to concepts such as therapy, something that would never have featured in Windsor-speak before.

The fact that she is a biracial divorced actress has been touched on previously, but it, too, shows how open the monarchy is to change. In 1936, an American divorcee caused the downfall of a king amid the Abdication Crisis: in 2018 no one batted an eyelid. Instead, there was widespread rejoicing that Harry had finally met someone who was going to be the Duchess of Right: the loss of his mother at such a young age and the failure of his two significant relationships before Meghan had produced in Harry a desire to settle down. One of the most popular of the Royals, there was also a palpable need among the public to see him do so. The vast majority of the public was delighted at his choice: times were changing, and the Royals were changing, too.

The sibling to the monarch is always in a slightly tricky position: the Queen's sister, Princess Margaret, is often portrayed as a grand and difficult woman who never really seemed to find

a role in life. But Margaret had been denied the chance to marry the great love of her life, Group Captain Peter Townsend, and there had always been a sense that that event cast a shadow that never left her. Harry, on the other hand, was being allowed to marry exactly who he wanted, and he made it clear from the outset that they were going to work as a team. Meghan's commitment to their future was equally great: she was going to be a member of the Royal Family, but she was sacrificing a great deal in order to do so. She was leaving her country, her career, her nationality, even her lifestyle – for, no matter how great the opportunities and luxuries that lay before her, she was also sacrificing her freedom. The life of a modern princess is not a fairy tale. It involves a lot of hard work.

But then, unlike any Royal bride before her – even Kate Middleton – Meghan had been a career girl. She knew the value

BELOW:

Cheering crowds carrying the Welsh flag greet Harry and Meghan as they visit Cardiff Castle in January 2018.

OPPOSITE:

Unusually for the Royals, Harry and Meghan signed autographs for the waiting crowds.

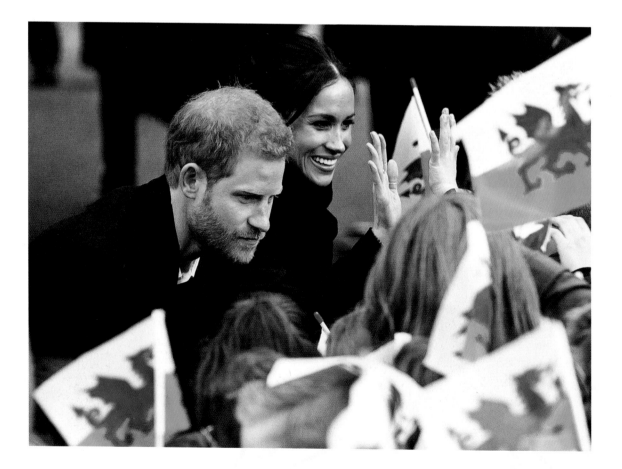

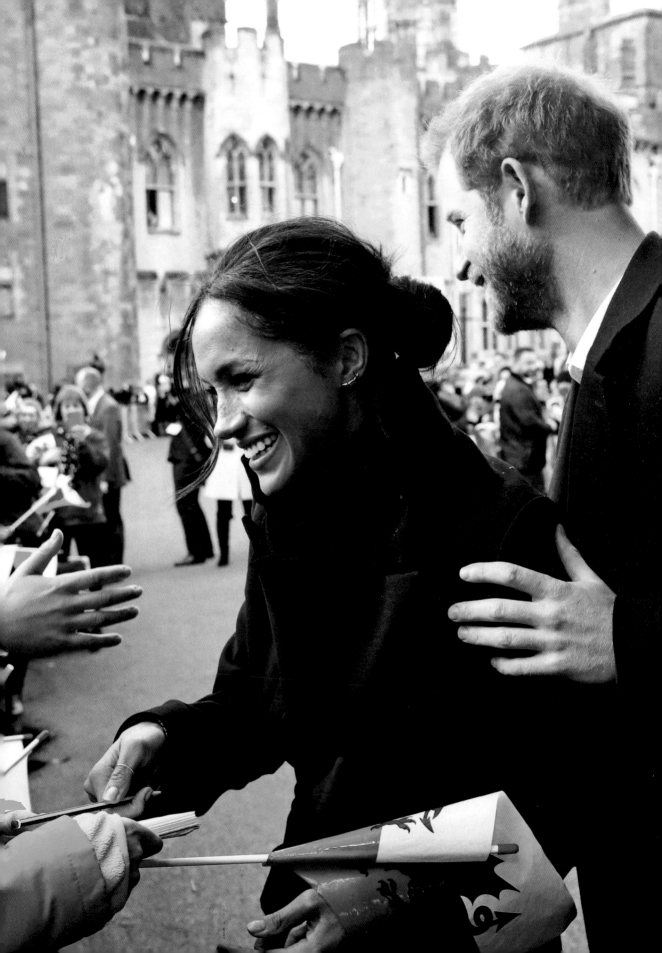

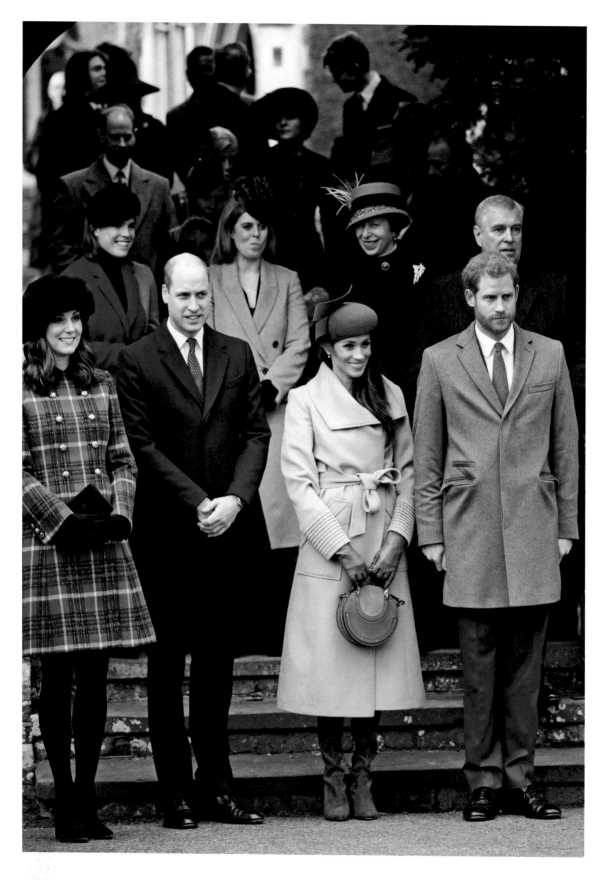

of hard work. She was not an ingénue coming into a situation she didn't fully understand; she was a mature woman who had made her name in the cut-throat world of television. She was also clearly able to provide the steadying influence that Harry needed, and was clearly prepared to take on the responsibilities of being a Royal bride.

But significant changes were happening even before the wedding itself. For a start, Meghan was being absorbed into the most senior Royal groupings: previously Harry had teamed up with his brother and sister-in-law to draw attention to issues that concerned them and now Meghan was being drawn into this too. They had all been pictured together at Sandringham over Christmas, but now they were seen in a more formal context when they appeared in February at the first annual Royal Foundation Forum, a charity set up by William, Kate and Harry and of which Meghan would also become a patron after the wedding.

And Meghan could not have fitted in more perfectly. The four were seated on a row of chairs under the slogan "Making a difference together", with Meghan in a Jason Wu navy wrap dress and Kate, now conspicuously pregnant, in a blue Seraphine maternity dress. William opened the proceedings by welcoming Meghan with the words that they were "particularly happy" that this was the first such event with Meghan. Unsurprisingly, this got a round of applause.

"Ten years ago Harry and I were still serving full-time in the military, but we were starting to look to the next stages of our lives," William continued. "As we discussed together the best way to set out on our official work, we looked to the values our family had instilled in us. Both our parents had provided for us an example of diligence, compassion and duty in all they did. Our grandparents, The Queen and The Duke of Edinburgh, had made support for charity central to their decades of service to the nation and the Commonwealth. The task for us would not be to reinvent the wheel. Instead, our job was to follow the example of those who had come before us, hold on to the values that have always guided our family, but seek to engage in public life in a way that was updated and relevant for our generation. Today we want to celebrate this spirit of togetherness. We want to reflect on what we've achieved. And we want you to work with us as we consider what we might do next."

OPPOSITE:

The two brothers and their significant others stand in front of the rest of the Royal Family as they wait to see off the Queen after the Christmas Day church service.

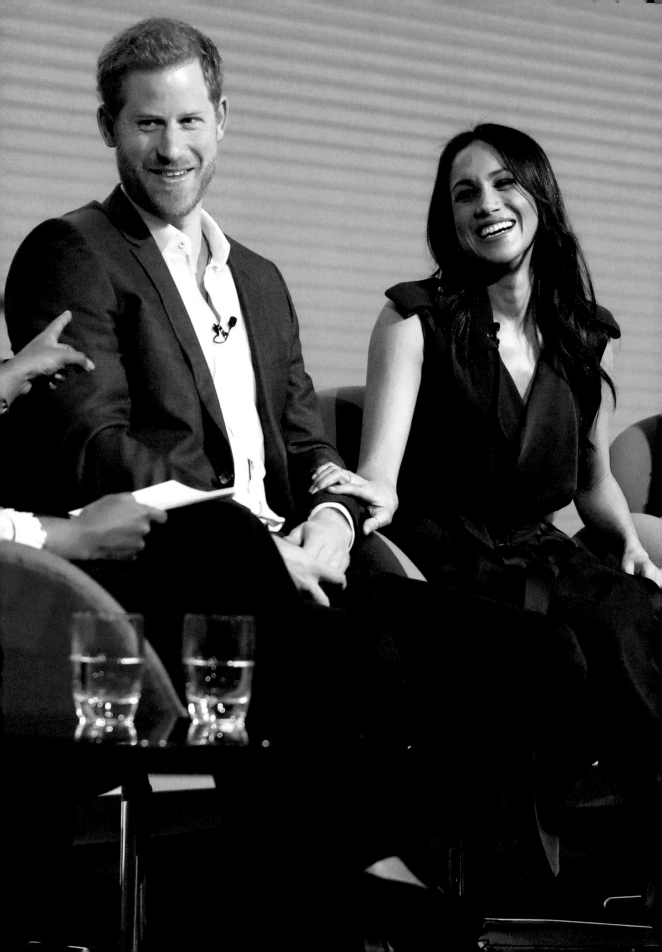

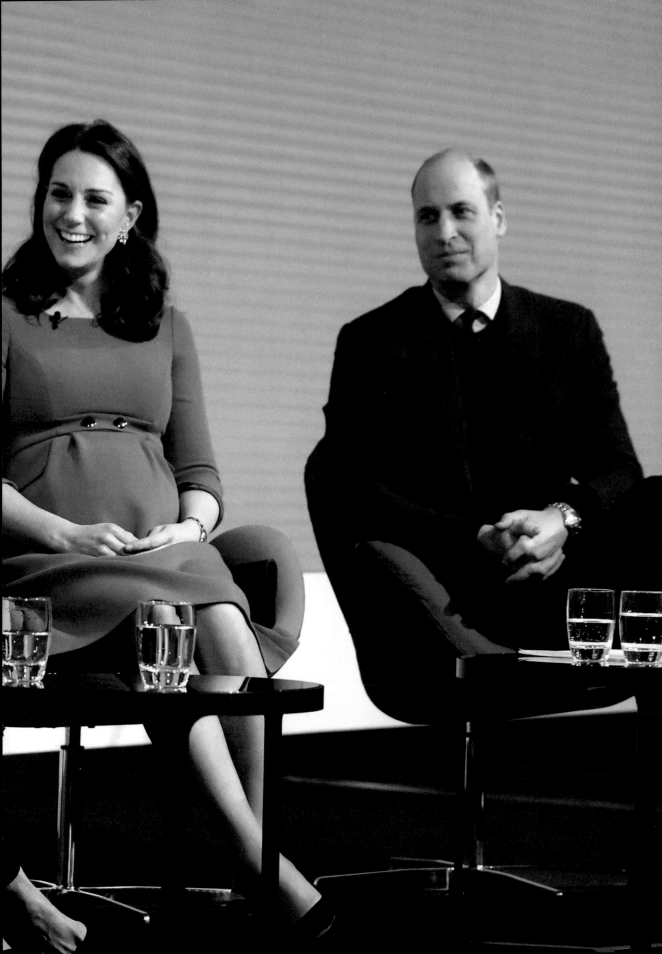

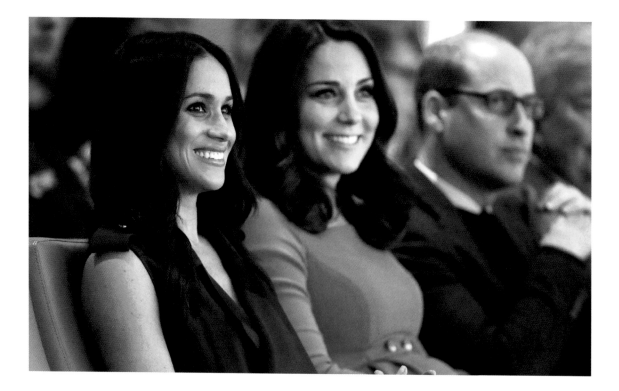

Each of what was inevitably dubbed the Fab Four then had their turn. Kate spoke about Heads Together, the campaign she, William and Harry had been running to dismiss the stigma of mental illness, while other causes such as United For Wildlife and the Invictus Games were discussed. Harry made a lighthearted reference to what lay ahead: "We're pretty much tied up with planning a wedding but we want to make as much difference as we can," he said, turning to Meghan, who beamed at him in return.

Meghan also had her turn. In the past she had spoken a lot about women's rights and did so here too, except that this was in the wake of the revelations about the behaviour of the Hollywood producer Harvey Weinstein and a slew of other stories about men in public life. Women, especially high profile Hollywood women, had had a lot to say about this and Meghan was no exception.

She wanted to "hit the ground running" after marrying Harry and speak up for women's rights. She said, "we can hold tight until that's done." Even so she tackled the issue head on. "I hear a lot of people speaking about girls' empowerment and women's empowerment; you will hear people saying they are helping women find their voices," she said. "I fundamentally disagree

with that because women don't need to find their voices, they need
to be empowered to use it and people need to be urged to listen.
Right now with so many campaigns like #MeToo and Time's
Up there's no better time to continue to shine a light on women
feeling empowered and people supporting them."

In truth there was a tiny raising of eyebrows in some corners,
because the Royal Family is expected to avoid controversy and
politics and this particular issue was not the kind of thing they
would have talked about in the past. But that was to ignore the
fact that the monarchy was changing with the times. William,
Kate and Harry had gone public about causes they supported,
especially mental health, before Meghan came on the scene: she
was merely doing exactly what they had done. And Harry had
fallen in love with a woman who – like his mother – was already
an ardent campaigner. He was hardly going to want her to stop.

However, some traditions were going to remain the same. In
early March, it emerged that Meghan was going to be baptized
into the Anglican faith by the Archbishop of Canterbury in
a private service at St James's Palace, although given that the
announcement had previously been made that this was on the
cards, it was hardly a surprise. Holy water from the River Jordan
was used, with the Prince of Wales and Duchess of Cornwall in
attendance. She was then confirmed immediately afterwards. "It
was very special, it was beautiful and sincere. And it was very
moving," the Archbishop said in a television interview with *ITV
News* some time later. He also confessed to nerves when it came
to conducting the forthcoming wedding ceremony: "Unlike recent
weddings, I must not drop the ring. And I must not forget to get
the vows in the right order, as I did at the rehearsal for one of my
children's weddings. You know, at the heart of it is two people
who have fallen in love with each other, who are committing their
lives to each other with the most beautiful words and profound
thoughts, who do it in the presence of God. Through Jesus Christ
you pray for them to have the strength to fulfil their vows and you
seek to do it in a way that respects their integrity and honours
their commitment. You just focus on the couple. It's their day.

"You talk about what they want in the wedding, discuss it with
the Dean of Windsor, it's what you do for weddings, it's just on an
infinitely larger scale."

In March Meghan spent three nights at fashionable Soho
Farmhouse in the Cotswolds, with friends including Millie

Mackintosh, Misha Nonoo and Violet von Westenholz all there. It is a celebrity favourite, previously visited by Harry and Meghan, complete with a luxury spa, and a much needed break from the massive publicity that now surrounded her every move. But she and Harry were determined to keep up with the campaigning: they marked International Women's Day by attending an event in Birmingham designed to encourage young women to study science, technology, engineering and maths, traditionally subjects more associated with men. She also showed more of the star quality synonymous with the mother-in-law she would alas never meet: she made headlines when she gave 10-year-old Sophia Richards a

BELOW:

Attending the couple's most high-profile public engagement to date, the Commonwealth Day Service.

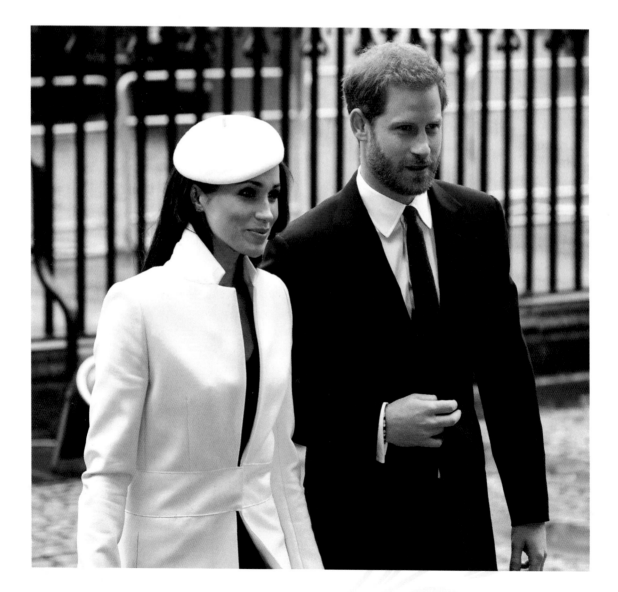

big hug. The little girl could barely contain herself: "They told me I can achieve whatever I want to achieve," she said afterwards, still clearly wildly excited. "And Meghan said she would like to see me on TV when I become an actress. It was a dream come true. I will never forget this day."

Shortly afterwards came the couple's biggest engagement together to date. They attended the Commonwealth Day Service at which the Queen was also present along with other senior Royals: it was commented on that not only did Meghan know the words of the National Anthem but that Kate had not attended such a senior engagement until she and William were wed. Wearing a cream coat by Amanda Wakeley and a beret by Stephen Jones, she was her usual stylish self, before the two of them attended a reception afterwards. It emerged that the couple had also had a private lunch with the Queen shortly beforehand; the two women had met before, of course, but it was a clear sign how keen the senior Royals were to welcome Meghan into their midst.

After the wedding, there will, of course, have to be changes. Nott Cott is perfect for a newly married couple, but it is not big

ABOVE:

Prince Harry and Meghan Markle visit Nechells Wellbeing Centre in Birmingham, where apprentices take part in a scheme designed by The Royal Foundation. Engaging with communities supported by the Royal Foundation will be hugely important in Meghan's life as Harry's wife.

enough for a growing family and, if the couple have children, they will almost certainly have to move to one of the grander abodes at Kensington Palace. But to a certain extent, they will be able to live their lives in their own way, in a manner that William and Kate cannot. Being the "spare" to William's "heir" might have some drawbacks, but it does mean that Harry will have more flexibility than his brother ever did or will have. Harry has made it plain he wishes to be a campaigning Royal, just like his mother before him, and he has also, so far, skilfully negotiated the pitfalls that his father sometimes slips into: namely, avoiding anything that is too political. The Windsors cannot allow themselves to have any perceived political bias. The Queen has spent a lifetime managing to stay above the realm of politics and both her grandsons by Charles seem set to do the same.

So it looks as if Harry and Meghan will continue rewriting the rule book, even as they settle into married life. And the wedding comes at an auspicious moment. As life in Britain looks fractious and difficult due to the changing political situation in Europe and across the Atlantic, the Royal Family are doing what they have so often done before: uniting the country behind them. This country does royalty and pageantry as no other, and Harry and Meghan are just the latest thoroughly modern chapter in a story that has continued for a thousand years. Invitations to the wedding will be sought after, and interest in their married life will continue to burn as strongly as ever, especially if and when they start building a family. But the signs are that theirs is a stable relationship, with each complementing the other. Together, as in all the best relationships, they are stronger than the sum of their parts.

BELOW:

At a reception for young people at the Palace of Holyroodhouse, the Queen's official residence in Edinburgh.

OPPOSITE:

Walking side by side, together, through the Palace of Holyroodhouse.

NEXT PAGE:

Enjoying a visit to Social Bite, a social enterprise café that is tackling homelessness in Edinburgh.

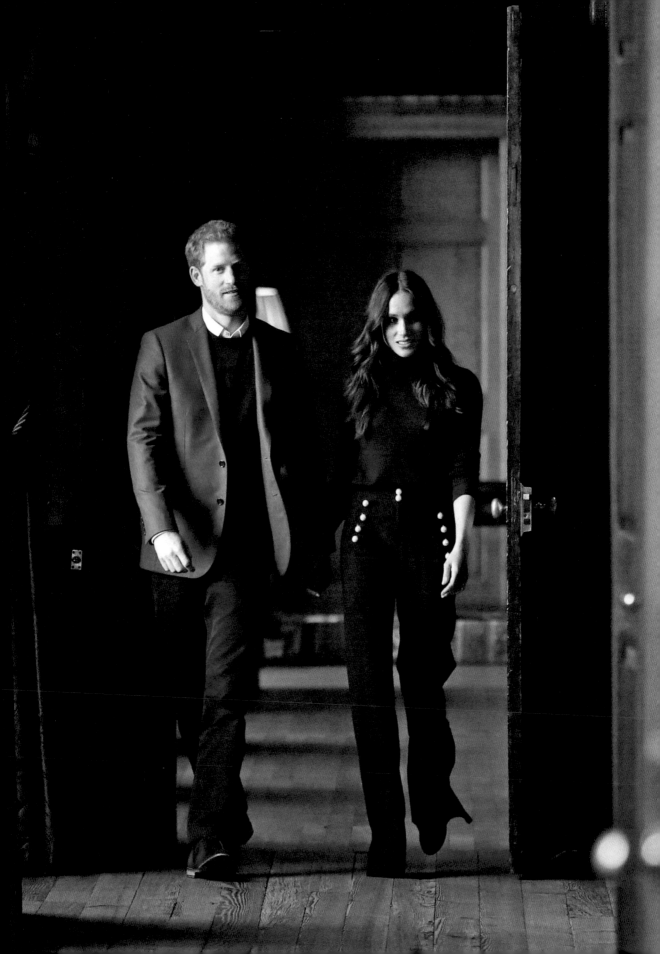

WE MET SONNY WHEN HE CAME INTO SOCIAL
BITE FOR FREE FOOD. HE WAS A RECOVERING
HEROIN ADDICT AND IN AND OUT OF
AFTER PLUCKING UP THE COURAGE
A JOB, HE HAS NOW BEEN EM
SOCIAL BITE FOR 3 YEARS. HA
BEING TRAINED AT OUR NE

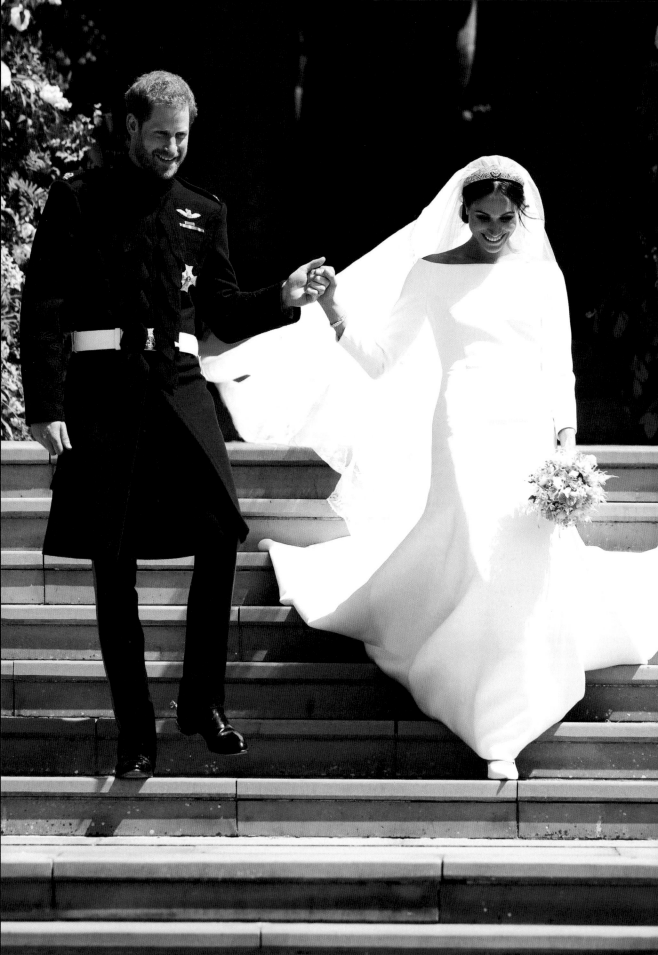

CHAPTER 6

THE WEDDING

"THERE IS POWER IN LOVE. DON'T UNDERESTIMATE
IT. NOT JUST IN ITS ROMANTIC FORMS, BUT ANY
FORM, ANY SHAPE OF LOVE. WHEN YOU ARE LOVED
AND YOU KNOW, WHEN YOU LOVE AND YOU SHOW IT...
IT ACTUALLY FEELS RIGHT."

BISHOP MICHAEL CURRY, DURING HIS ADDRESS TO THE CONGREGATION

Saturday, 19 May 2018, St George's Chapel, Windsor. It was a glorious sunny day with a palpable air of excitement. The crowds had been assembling for days now, starting with the rehearsal, which had taken place two days previously, with diehards camping out overnight. By the morning of the wedding itself a crowd of 100,000 was present, and there was no hope at all for anyone turning up late. The anticipation was rising. Prince Henry Charles Albert David of Wales was breaking with almost every conceivable Royal tradition and marrying Rachel Meghan Markle, a biracial divorced actress who originally came from the United States.

The run-up to the wedding had been uphill, with Meghan's father Thomas deciding at the last minute not to attend, and with her various step-siblings giving their own take on developments to the hungry press. But all this was forgotten as excitement mounted within the crowd eagerly waiting to cheer on Harry who, with his brother William, had been staying at nearby Coworth Park, and Meghan, staying with her mother at Cliveden House. The crowds were certainly entering into the spirit of the occasion: wrapping

PAGE 98:

Positively beaming, the newlyweds descend the steps of St George's Chapel.

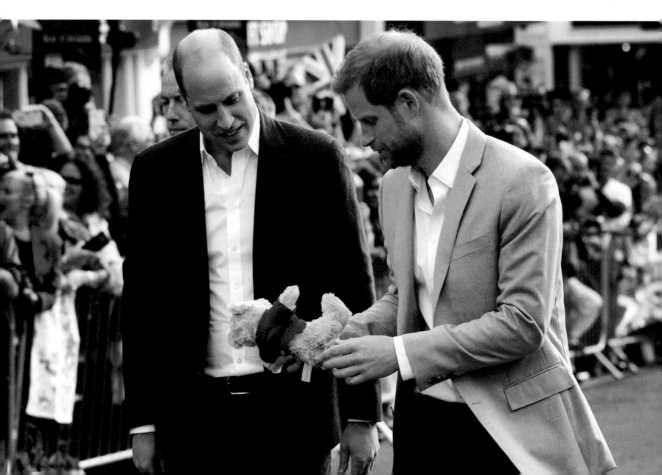

OPPOSITE:

Princes Harry and William greet members of the public on a walkabout the day before the wedding.

RIGHT:

Meghan and her mother, Doria, arrive at Clivedon House Hotel on the National Trust's Clivedon Estate, where they spent the night before the wedding.

BELOW RIGHT:

Royal fans gather outside Windsor Castle. Tens of thousands of well-wishers descended on Windsor to celebrate the couple's big day.

themselves in the Union flag and cheering. This was modern Britain and a modern monarchy.

However, one Royal tradition was maintained: on the morning of the wedding, it was announced that Harry and Meghan would be given new titles. They were to become the Duke and Duchess of Sussex. There had only been one previous Duke of Sussex and, although he had been married twice, his father, George III, had not approved of the matches. This meant that Meghan was to be the first woman ever to be allowed the title HRH the Duchess of Sussex, and may also be known as Princess Henry of Wales. She had well and truly joined "the Firm". Also in keeping with Royal tradition, Harry had further titles: Earl of Dumbarton and Baron Kilkeel.

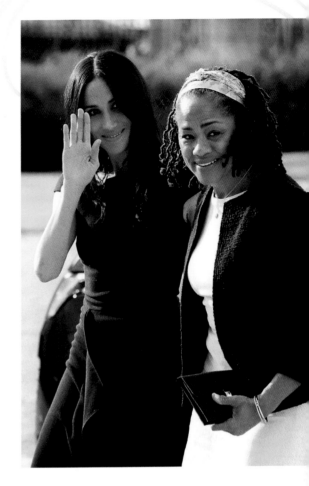

LEFT:

Flag in hand and decked from head to toe in Union flags, a fan waits on the Long Walk the day before the wedding.

BELOW:

Over 2,000 guests were invited to the Windsor Castle grounds. In the spring sunshine, they await the arrival of the bride and groom.

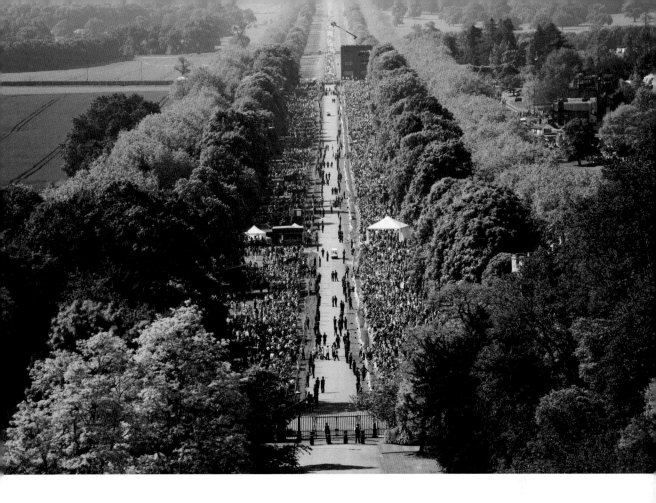

ABOVE:

*Spectators gather
on the Long Walk,
eagerly awaiting
a glimpse of the
newlyweds.*

There were 2,640 charity workers, community champions and local school children watching the wedding from within the walls of Windsor Castle. At around 9.30am the 600 guests began to arrive, having been previously told to meet at the Windsor Farm Shop. They congregated at the Round Tower and entered St George's Chapel through the South Door, before taking their seats. It was a case of royalty meets show business. George Clooney was there, with his wife Amal in a vivid yellow outfit, along with Idris Elba and his fiancée Sabrina Dhowre, Sir Elton John and David Furnish and Oprah Winfrey. The Beckhams were in attendance, David hiding his tattoos under a morning suit, Serena Williams and her husband Alexis Ohanian, James Corden and his wife Julia Carey, James Blunt and wife Sofia Wellesley and Meghan's on-screen husband Patrick J. Adams, who was invited to see her real-life wedding. Some of the other members of the *Suits* crowd were there as well. There were no American presidents, either in situ or now out of office. Harry and Meghan would almost certainly have liked to invite the Obamas, but although they were

OPPOSITE:

Television presenter Oprah Winfrey, said to be a friend of Meghan's, arrives wearing lace-trimmed pale pink.

ABOVE RIGHT:

Former England footballer David Beckham and fashion designer Victoria Beckham arrive. Meghan wore a cashmere sweater from Victoria's luxury brand in one of her official engagement photos.

allowed to get their own way in many respects, this may have been a controversial move.

Harry's two ex-girlfiends Cressida Bonas and Chelsy Davy were also invited. And of course the Royals were out in force: Harry's Windsor uncles and aunt and all their offspring, including a heavily pregnant Zara Tindall; his Spencer cousins Eliza, Louis and Kitty and their mother Victoria Aitken; Pippa Middleton and the Middleton parents, Carol and Michael, with Carol in

ABOVE LEFT:

British actor Idris Elba and fiancée Sabrina Dhowre – in patriotic red, white and blue – arrive at St George's Chapel.

ABOVE RIGHT:

Actress Carey Mulligan arrives in an embroidered dress by British designer Erdem, accompanied by musician husband Marcus Mumford.

RIGHT:

James Corden hand in hand with his stylish wife Julia Carey.

OPPOSITE ABOVE:

George Clooney with his wife, human rights lawyer Amal, who wowed onlookers in her striking yellow Stella McCartney dress.

BELOW LEFT:

Meghan's friend, Suits co-star and on-screen husband Patrick J. Adams, accompanied by his wife Troian Bellisario.

BELOW RIGHT:

Two of Meghan Markle's closest friends, actresses Abigail Spencer and Priyanka Chopra, who looked stylish in Alessandra Rich and couture Vivienne Westwood respectively.

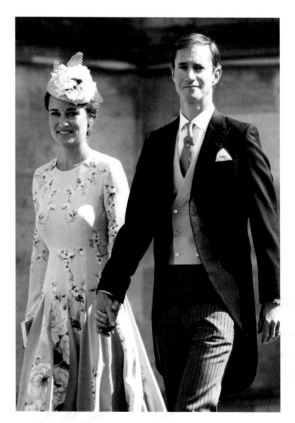

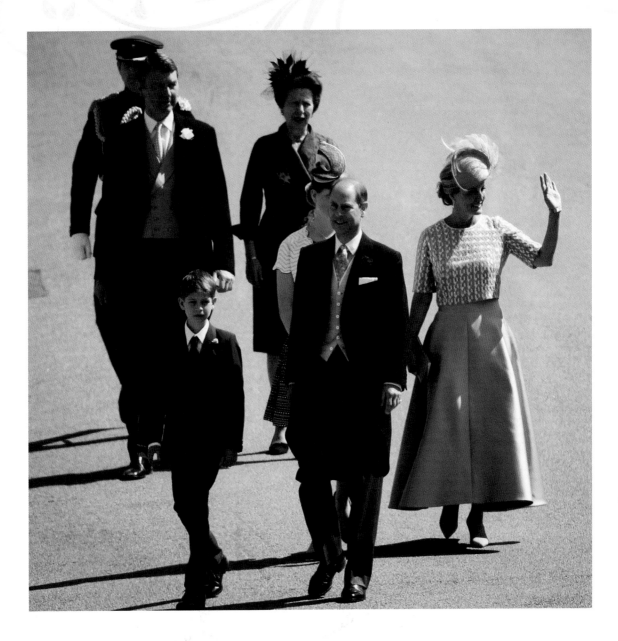

**OPPOSITE
TOP LEFT:**

Princess Eugenie of
York, who will marry
Jack Brooksbank in
St George's Chapel
later this year.

**OPPOSITE
TOP RIGHT:**

Princess Beatrice
of York in a heavily
beaded Roksanda
teal gown.

**OPPOSITE
BOTTOM LEFT:**

Mike and Zara Tindall,
who are expecting
their second child,
the Queen's seventh
great-grandchild.

**OPPOSITE
BOTTOM RIGHT:**

Pippa Middleton and
James Matthews, who
married in 2017.

ABOVE:

Prince Edward, Earl
of Wessex, Sophie,
Countess of Wessex
and James, Viscount
Severn, followed by
Princess Anne and
Vice Admiral Sir
Timothy Laurence.

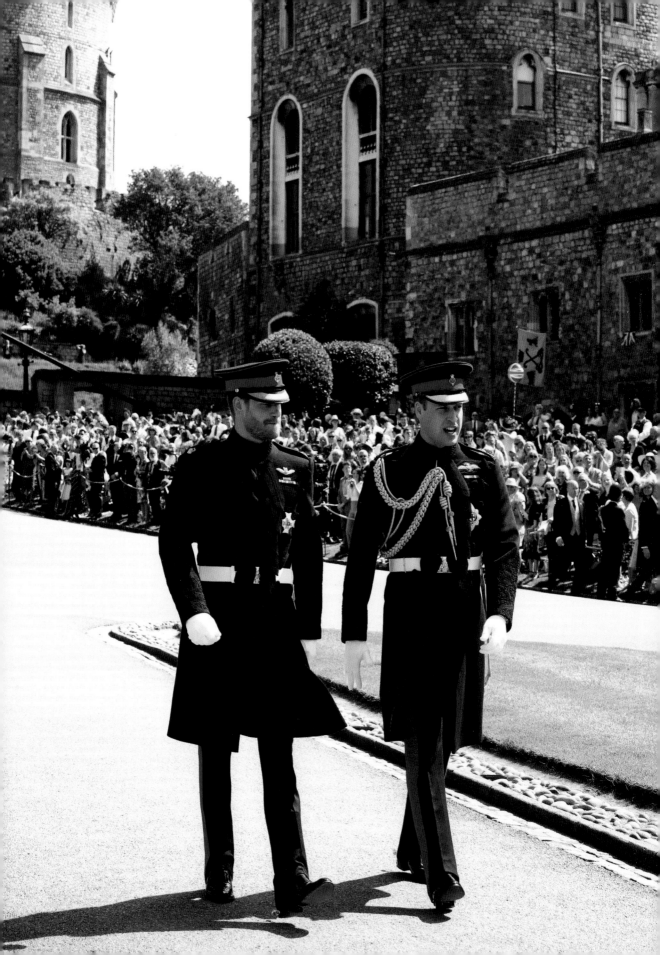

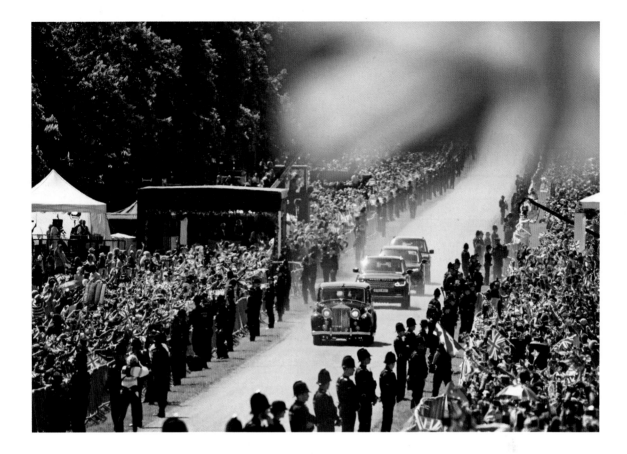

PAGES 110-111:

Prince Harry and the
Duke of Cambridge
greet the crowds of
invited guests in the
grounds of Windsor
Castle, as they
make their way to St
George's Chapel.

OPPOSITE:

The first glimpse of
the groom and the
best man, who both
wore the frock coat
uniform of the Blues
and Royals.

Catherine Walker. All three of Princess Diana's siblings were in the congregation, with Lady Jane Fellowes giving the reading and Lady Sarah McCorquodale and Earl Spencer looking on.

There were cheers from the crowds, intensifying as members of the Royal Family began to arrive and enter via the Galilee Porch: this reached a crescendo as the groom, clad in military uniform, the frock coat of the Blues and Royals, and accompanied by his best man (or "supporter", as the Royals term it), the Duke of Cambridge clad in the same uniform, came into view. The two paused briefly in a side chapel before seating themselves at the front. Harry looked a little nervous; his elder brother was making a visible effort to calm him down. Elsewhere Meghan's car came into view; she was cheered as it turned into the Long Walk.

The three parents then arrived: an exquisitely elegant Doria Ragland, in a chic two-piece light green dress and coat by Oscar de la Renta, with matching hat, was greeted at the South Door, before sitting at the far end of the Quire. She looked remarkably composed given the occasion. The Prince of Wales, who was said

ABOVE:

Meghan's wedding
car travels down
the Long Walk to
cheers from the
excited crowds.

to be deeply touched when Meghan asked him to talk her to the altar in the absence of her father, then appeared, along with a pink-clad Duchess of Cornwall in Anna Valentine. And then the Queen, dressed in a striking lemon silk dress by Stewart Parvin, appeared, with the 96-year-old Duke of Edinburgh. There had been speculation as to whether the Duke – retired from Royal duties – would attend, having recently undergone a hip operation, but he appeared chipper and clearly determined to witness the big day. All settled into the magnificent surroundings of the Chapel, redolent of centuries of tradition and of the 1,000-year-old monarchy into which Meghan was marrying.

Finally the bridal party, the bridesmaids and pageboys, who were the offspring of the couple's friends and, of course, the Duke of Cambridge, arrived, accompanied by various parents including the Duchess of Cambridge. Kate was dressed in a demure yellow coat by Alexander McQueen and a stylish flower-adorned hat

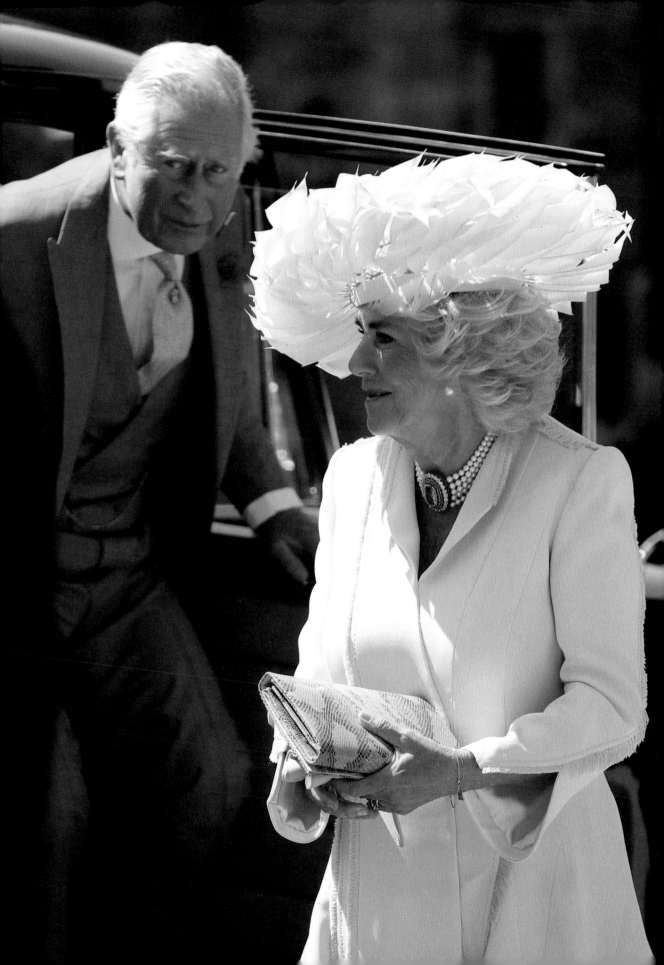

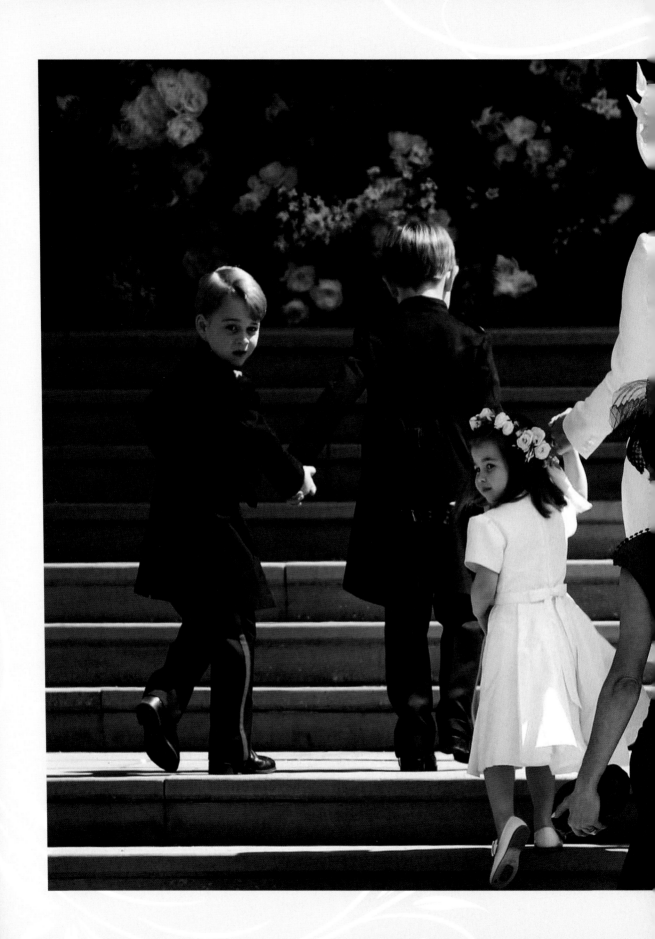

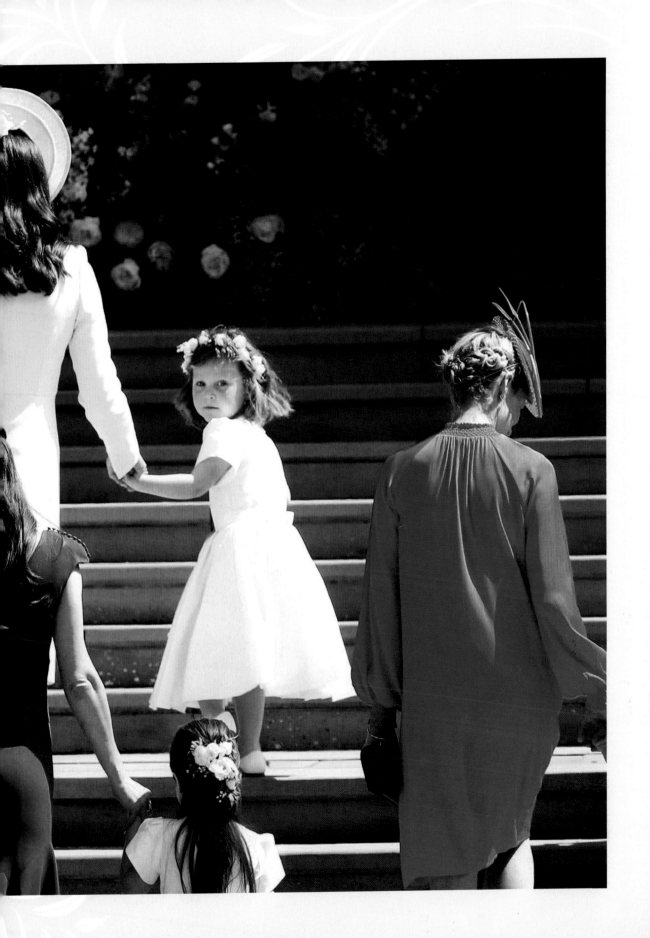

by Philip Treacy; she looked her usual radiant self after giving birth only a few weeks previously. The troupe of little ones was made up of Princess Charlotte, Florence van Cutsem, Remi Litt, Rylan Litt, Ivy Mulroney and Zalie Warren. Charlotte, clearly already a Royal pro, waved to the crowds, while the children were given flowers on entering the church. The pageboys were Prince George, Jasper Dyer, son of Harry's friend and mentor Mark, and Brian and John Mulroney, seven-year-old twin sons of Meghan's stylist friend Jessica. And they had a special role to play. When Meghan stepped out of a Rolls-Royce Phantom and revealed her beautifully elegant classic bridal gown by British designer Clare Waight Keller – artistic director at Givenchy – it was the little Mulroney boys who got out of the car with her, arranged her long train and who carried it aloft up the steps as she entered St George's Chapel. The veil and train were held in place by the Queen Mary Diamond Bandeau, made in 1932 and on loan from the Queen, while the veil itself featured intricately embroidered flowers from every country in the Commonwealth.

BELOW:

The bride arrives at St George's Chapel, accompanied by her mother, Doria.

OPPOSITE:

Meghan enters, her dramatic train held aloft by twin brothers Brian and John Mulroney.

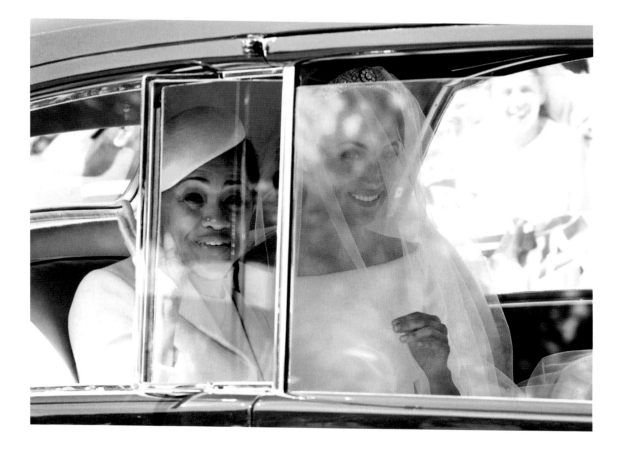

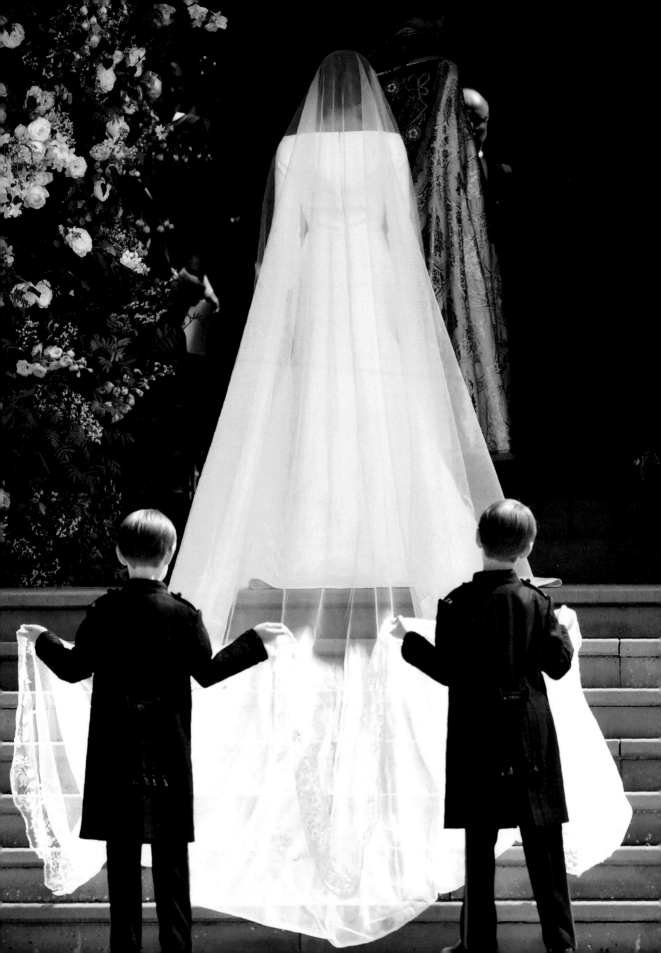

Meghan looked composed as, in another first for a Royal wedding, she walked herself up the first part of the aisle, with her cluster of bridesmaids and pageboys behind her, before Prince Charles stepped forward and accompanied her up to the altar. Harry appeared to whisper, "Thank you, Pa," before beaming at Meghan: "Hello," he said. The Dean of Windsor, David Conner, stepped up and the service began. Referring to the couple with their birth names Henry and Rachel, the vows began, and there was laughter as Harry's firm "I will" was met with cheering from outside the chapel. Meghan's tones in repeating her own vows were equally resolute.

Harry's aunt Lady Jane Fellowes, Princess Diana's older sister, rose to give a reading from the Song of Solomon: "My beloved speaks and says to me: 'Arise, my love, my fair one, and come

BELOW:

Meghan begins her bridal processional alone before reaching the Quire, where she will be greeted by Prince Charles.

OPPOSITE:

The look of love: Prince Harry gazes at his bride as Meghan arrives accompanied by Prince Charles.

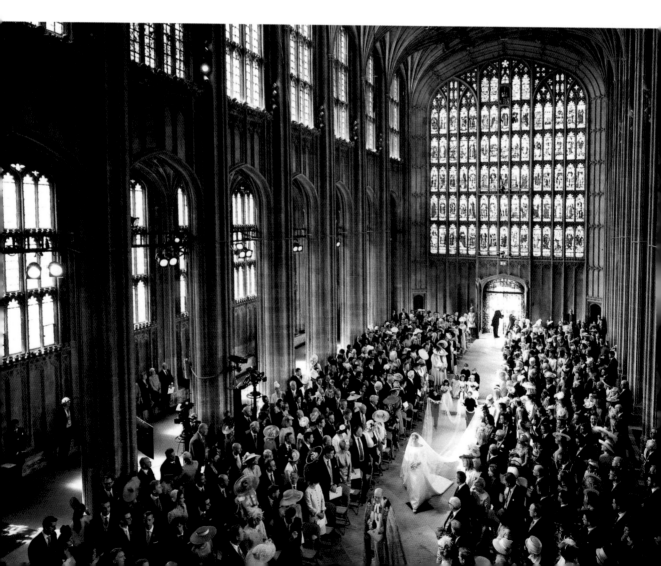

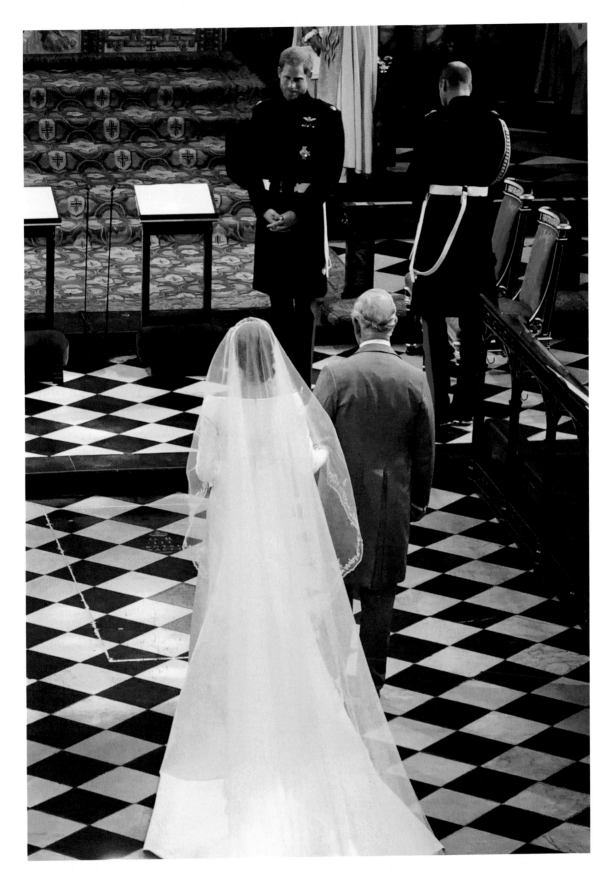

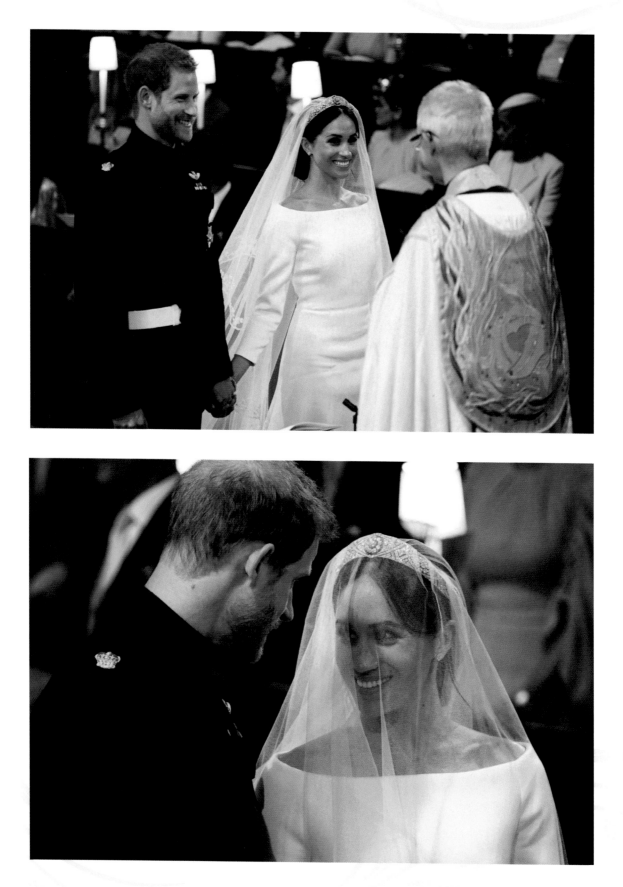

away; for now the winter is past, the rain is over and gone. The flowers appear on the earth; the time of singing has come, and the voice of the turtle dove is heard in our land.'"

Meghan's mother, Doria, clearly moved, looked as if she was holding back tears. Hymns began, and a besotted looking Harry and Meghan couldn't keep their eyes off one another: a fact that, as ever these days, was much commented upon on Twitter.

The chief celebrant was, of course, the head of the Anglican Communion, the Archbishop of Canterbury Justin Welby, but the preacher was the American Episcopalian bishop and social justice campaigner Michael Curry. The first African American to be Presiding Bishop and Primate of the Episcopal Church, Bishop Curry now stepped up to give one of the most rousing addresses to be heard at a Royal wedding in many a long year. Its focus, aptly enough, was love, and he opened with a quote from Martin Luther King: "We must discover the redemptive power of love and when we do that we will make of this old world a new world," he began. "There is power in love. Don't underestimate it. Not just in its romantic forms, but any form, any shape of love. When you are loved and you know, when you love and you show it... it actually feels right." And more: "Two young people fell in love and we all showed up." Referencing the civil rights movement, poverty and the music of African American slaves, the sermon reflected the

OPPOSITE ABOVE:

The ceremony was spiritual and moving, but also a truly joyful occasion, especially for the couple themselves.

OPPOSITE BELOW:

An emotional moment: the couple gaze into each other's eyes. Harry was heard to have said, "You look amazing."

ABOVE:

Bishop Curry gives an impassioned and emotional address to the congregation.

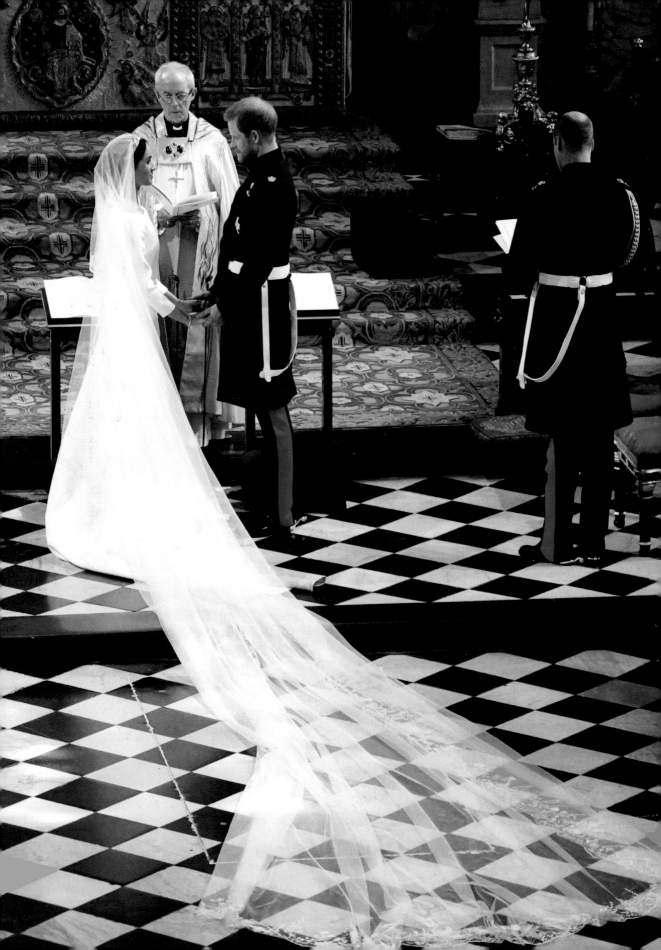

principles and humanitarian mission of the Royal couple, and put an intensely human slant on very regal proceedings.

With that, the pastor very nearly stole the show, delivering an impassioned address that had many members of the congregation beaming, almost laughing, in delight. Addressing his audience as "brothers and sisters" he continued, "When love is the way, we will let justice roll down like a mighty stream and righteousness like an ever-flowing brook. When love is the way, poverty will become history. When love is the way, the earth will be a sanctuary... When love is the way, we will lay down our swords and shields down by the riverside to study war no more. When love is the way, there's plenty good room, plenty good room for all of God's children. Because when love is the way, we actually treat each other, well, like we're actually family." He compared love to fire, pointed out that although he had crossed the Atlantic to get there he had not actually walked on water and then, seemingly realizing he had possibly been speaking for longer than expected, announced, "We gotta get you all married!" It went down so well that some people joked that if Pippa Middleton had been the unexpected star of Kate and William's wedding, then Michael Curry was the star of this one.

The music was another key element of the service. James Vivian, Director of Music at St George's Chapel, was in charge of the music, although Harry and Meghan certainly brought their own personal touches to proceedings. During the ceremony, the Choir of St George's Chapel, which was made up of 23 boys and 12 adult men and formed in 1348, performed the music. There was a larger orchestra, made up with musicians from the BBC National Orchestra of Wales, the English Chamber Orchestra and the Philharmonia, led by conductor Christopher Warren-Green. Harry and Meghan's personal tastes and pride in Meghan's heritage were reflected by the Christian gospel group, Karen Gibson and the Kingdom Choir, who performed "Stand By Me" by Ben E. King.

OPPOSITE:

Barely taking their eyes off each other, the couple exchange vows during their wedding ceremony.

The service continued, with the couple exchanging vows and rings – unlike most Royal grooms, Harry chose to wear a wedding ring – and as the bride and groom, along with Prince Charles and Doria Ragland, went off to sign the register, there was more music to enchant the congregation. First Luke Bond gave a performance on the organ and then attention switched to Sheku Kanneh-Mason, the award-winning 19-year-old cellist

who is a student at London's Royal Academy of Music and who, in 2016, was the first black musician to win the BBC's Young Musician of the Year. Meghan rang personally to ask if he'd play at their ceremony. The couple returned to the Quire after signing the register and as the congregation sang the National Anthem, Meghan clearly being word-perfect, Doria again was near tears. And so the newly married couple walked up the aisle, followed by their group of little attendants (it was also remarked upon quite how beautifully the children had behaved), to emerge to riotous cheering. Harry delighted everyone by kissing his bride and, under glorious sunlight, helped Meghan into the open-top Ascot Landau, one of five in the Royal Mews and one of the carriages used for coronations, Royal weddings and state visits. There had been back-up plans for a covered carriage if rain had appeared, but the weather could hardly have been better. The carriage was pulled by six Windsor Grey horses, including the father and son steeds, Storm and Tyrone.

The day could not have gone more smoothly, especially given the last-minute crisis involving Meghan's father, but the Windsors traditionally come second to none in organizing big events. And of course they had the most talented suppliers involved to help with every last detail. The flowers were provided by London-based florist Philippa Craddock, who had previously worked with Alexander McQueen and *Vogue*. Designs incorporated foliage

ABOVE:

Prince Harry tenderly places a wedding ring on Meghan's finger.

OPPOSITE:

The Duke and Duchess of Sussex proudly lead each other up the aisle, beaming at the congregation.

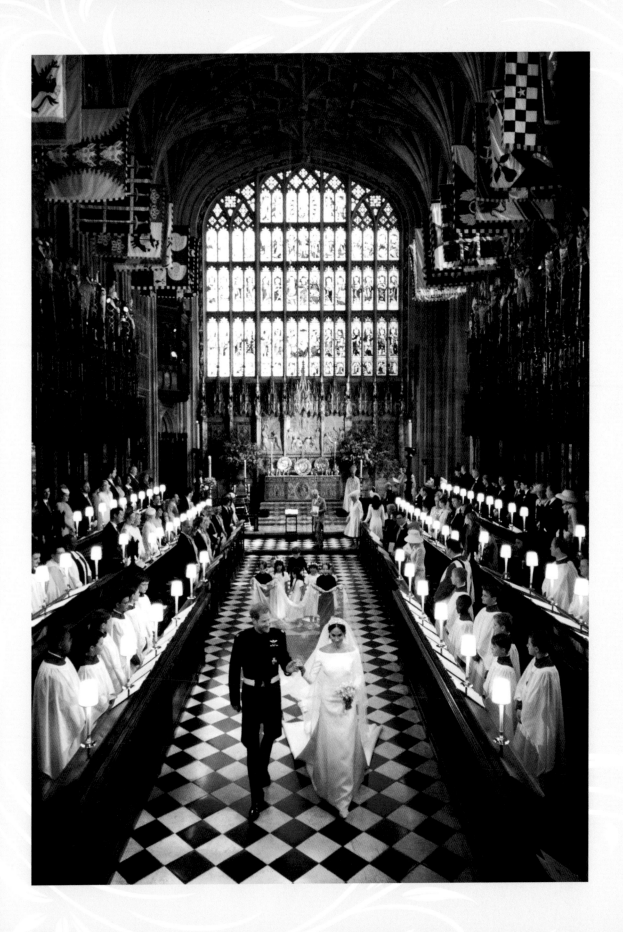

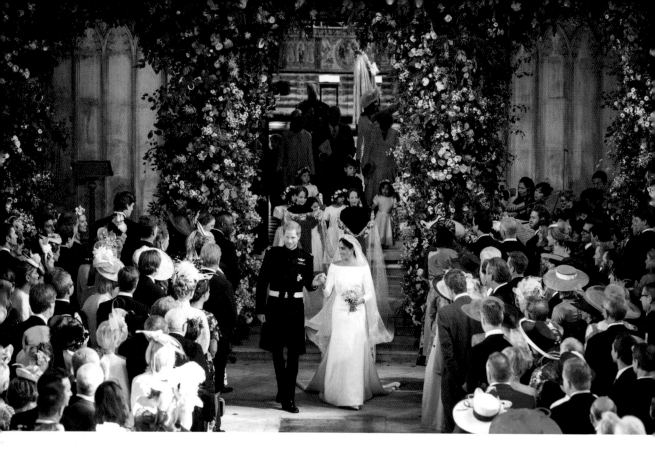

from Windsor Great Park, including beech, birch, hornbeam branches, white garden roses, peonies and foxgloves. Craddock directed a team of florists, including staff from St George's Chapel and Buckingham Palace, to create displays for St George's Chapel and for the first reception at St George's Hall, of which more below. Harry and Meghan arranged for the flowers to be distributed to charitable organizations after the wedding.

The Lord Chamberlain's Office at Buckingham Palace was responsible for much of the organization, working closely alongside Harry's Private Secretary, Edward Lane Fox, in order for the couple to put their own mark upon proceedings. The Royal Family paid for the wedding. Invitations were produced by Barnard & Westwood, which has Royal Warrants from both the Queen and Prince Charles. They were die-stamped in gold, featured the Prince of Wales feathers, the heraldic badge of the Prince of Wales, and specified that the dress code was "Uniform, Morning Coat or Lounge Suit" or "Day Dress with Hat".

Troopers of the Household Cavalry lined the staircase at St George's Chapel, and the streets within the castle grounds itself were filled by members of the Windsor Castle Guard from 1st

ABOVE:

Glorious floral arrangements embellish the arches of St George's Chapel, incorporating natural blooming branches of beech, birch and hornbeam.

OPPOSITE:

A perfect silhouette: the couple on the steps of St George's Chapel as they prepare to greet the thousands of well-wishers.

Battalion Irish Guards, and by Armed Forces from the Royal Navy Small Ships and Diving, of which Harry is Commodore-in-Chief, and the Royal Marines, where he is Captain General. The 3 Regiment Army Air Corps, where Prince Harry served as an Apache Pilot in Helmand Province, Afghanistan, was present alongside The Royal Gurkha Rifles, whom he served beside in Afghanistan, and RAF Honington, where he is Honorary Air Commandant.

The ceremony overran slightly, so it was at just after 1pm that the happy couple took a two-mile tour of Windsor, having left Windsor Castle by carriage via Castle Hill. Crowds whooped and cheered as they passed, reaching a crescendo as the duo passed a statue of Queen Victoria, while Meghan and Harry continued to gaze into each other's eyes. Meghan was, for the first time, on the receiving end of the full British adoration of the monarchy; although she had made public appearances before, there had been nothing compared to this. Across the Atlantic her father Thomas told TMZ, "My baby looks beautiful" and "I wish I were there and I wish them all my love and happiness." The other guests, headed by the Queen and Prince Philip, filtered out of the Chapel and prepared for the first of two receptions.

Meanwhile, a huge parade of serving officers lit up the streets of Windsor in a glorious display of pomp and circumstance following the Landau. They travelled along the High Street and Kings Road and returned along the Long Walk for the reception.

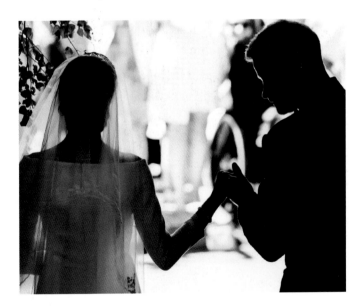

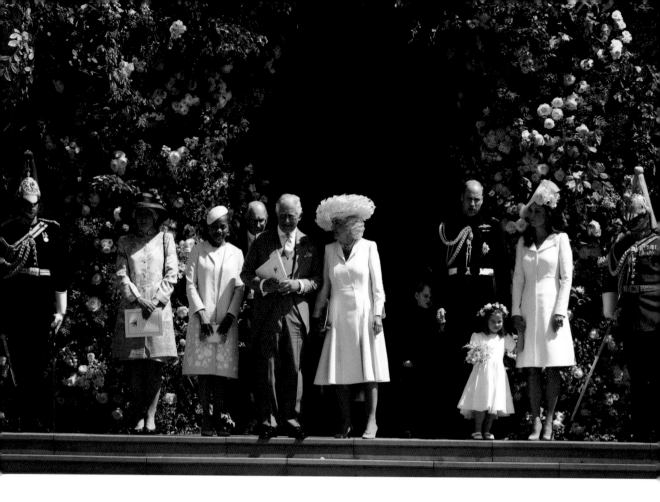

It was, as commentators noted, not just a very modern marriage: it was the first Royal multicultural marriage, with an African American Evangelical preacher, gospel singers, people plucked from all corners of society, and a new look for an institution that was 1,000 years old. It was the monarchy reinventing itself, as it had done time and again in the past. Nothing illustrated this better than the line-up outside the Chapel to wave the happy couple off: Doria Ragland was there with Prince Charles and Camilla, the Duke and Duchess of Cambridge and their children, Prince George and Princess Charlotte (their youngest, Prince Louis had been deemed too young to attend). Lady Jane Fellowes, who had given the reading, was there as well, standing on one side of Doria, with Prince Charles on the other.

Behind them a mass of other Royals were emerging, waving the happy couple off as they passed. The main wedding group descended the stairs of St George's Chapel, Prince Charles now flanked by Doria and his wife; the Queen and Prince Philip, the

ABOVE:

Doria Ragland, Meghan's mother, is welcomed into the fold as, after the ceremony, Harry's immediate family gathers outside the chapel.

latter still looking chipper despite his recent surgery, climbed into a waiting state Bentley and moved off.

But Harry and Meghan remained the stars of the show. They continued on their open-top carriage ride around Windsor accompanied by cheering crowds and a sea of Union flags alongside the Stars and Stripes. They headed up the Long Walk, with Meghan waving alongside Harry; there were two red-coated and gold-braided footmen in the carriage behind them (although one was, in fact, an armed Royal protection officer hiding his gun underneath his ceremonial dress). Meanwhile, a travelling Escort of the Royal Household, following on behind the Landau, lit up the streets of Windsor in a glorious display of pomp and circumstance. They travelled along the High Street, through the centre of Windsor and returned along the Long Walk for the first reception.

Meghan was positively glowing by this point and although Harry was used to the rapturous reception accorded to members of the Royal family, even he looked as though he could hardly believe the scene playing out in front of his eyes. The crowd was 10 or 20 deep along the way; the bride and groom were by now holding hands. In an atmosphere described as "infectious" someone cried out, "Three cheers for the Royal couple," and the crowd duly obliged. People were not only waving Union flags; they were wearing them too – in the shape of shirts and even headscarves. There were people present in Harry and Meghan masks, mock Beefeater uniforms and much else; the atmosphere was close to that of a carnival.

There were moments of high farce throughout the day as there were always bound to be on an occasion like this. The former butler Paul Burrell, who had worked for Princess Diana and had made a fortune writing books about her, was seen in a smart grey suit attempting to gain

BELOW:

The Duke and Duchess of Cambridge reunite with their children, pageboy Prince George and bridesmaid Princess Charlotte, after the ceremony.

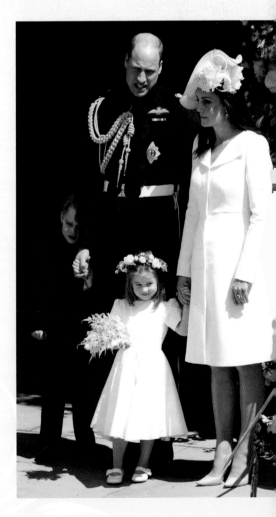

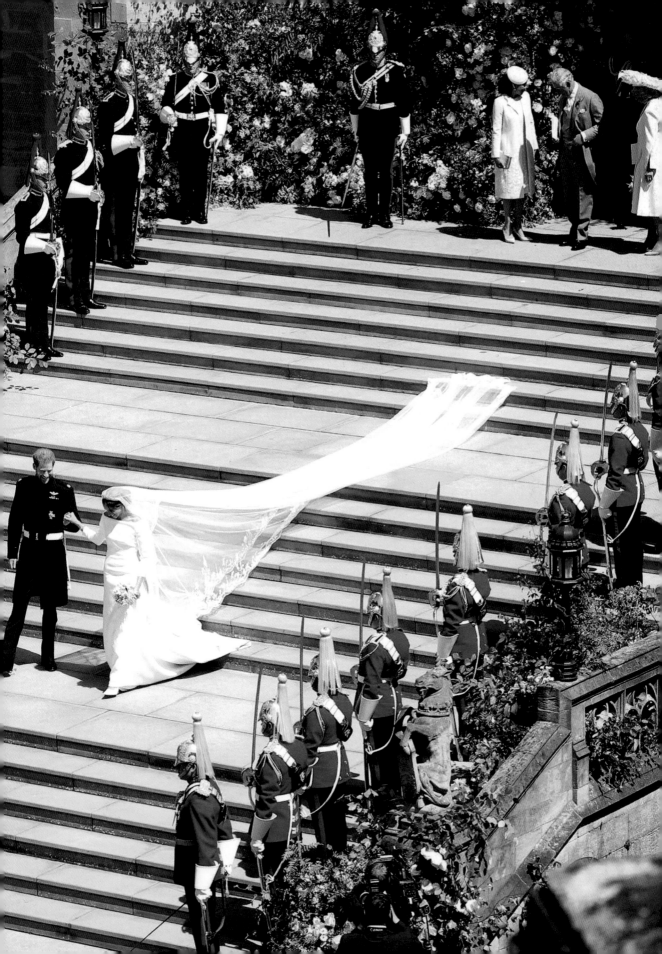

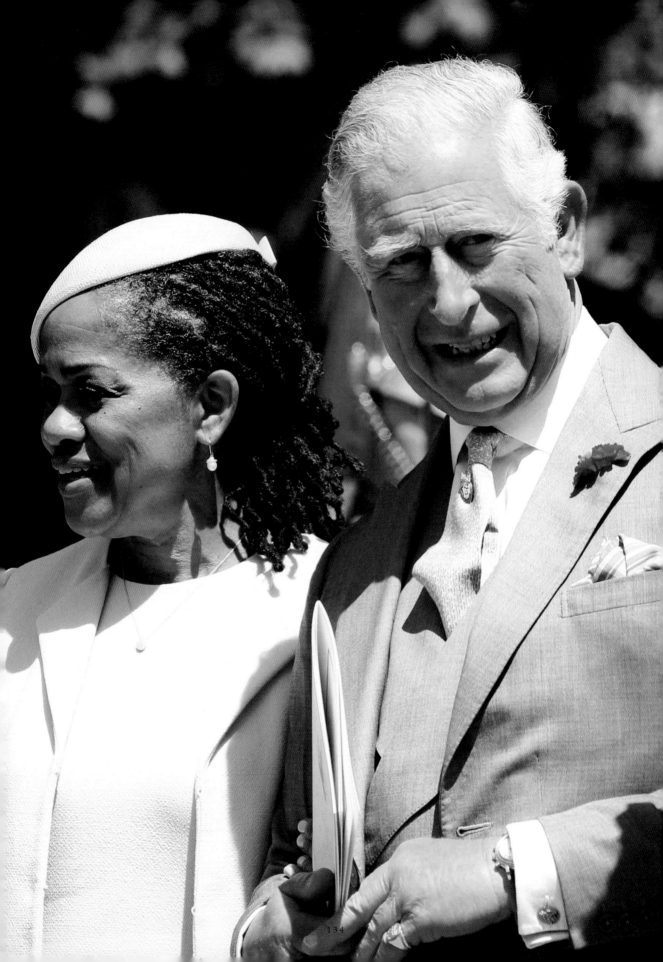

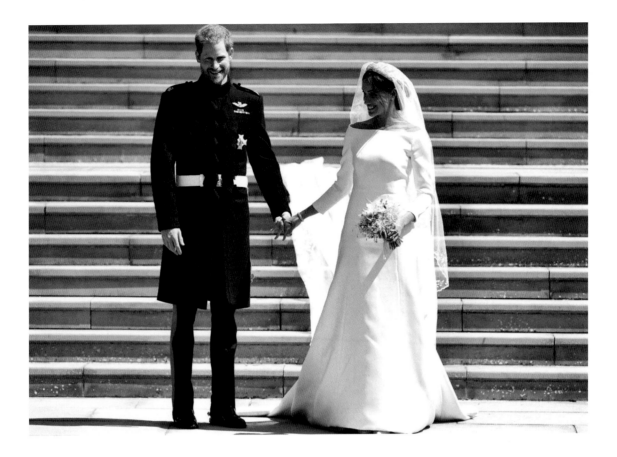

PAGES 132-133:

Troopers from Prince Harry's former army unit the Household Cavalry form the guard of honour as he and Meghan descend the steps of St George's Chapel.

OPPOSITE:

The mother of the bride and father of the groom are visibly overjoyed as they convene outside the Chapel after the ceremony.

access to the wedding, but he was not an invitee and was turned away. A couple of days earlier he had said that Diana would be there "in spirit", and indeed there were posters of Diana dotted around featuring that motif, but it was known that her sons had not been pleased with the books he had written about her and would not have wanted him there. Sarah Ferguson, the Duchess of York, was present throughout the service in a move some interpreted as a reconciliation with the Royal family, but some people thought she was Geri Halliwell. In actual fact Victoria Beckham was the only former Spice Girl present, although there had previously been speculation, which was wide of the mark, that the band would reform to play at the reception.

Elsewhere in the country there were celebratory street parties helped, of course, by the glorious weather. There were 93 in Richmond, south-west London, the highest number across the land. Streets were closed and decked with bunting, picnic tables laid out, barbecues held. Scotland celebrated, holding garden parties and afternoon teas and First Minister Nicola Sturgeon

ABOVE:

The newlyweds couldn't stop smiling at each other and the assembled photographers and well-wishers at the foot of the Chapel steps.

tweeted, "Many congratulations to the happy couple!" Scottish Conservative leader Ruth Davidson chipped in, "wonderful sermon, fabulous choirs and a young couple just looking smiley and happy." Everyone was tweeting, or posting on Instagram, including the wedding guests, Victoria Beckham and Jessica Mulroney among them. The latter put a picture of her twins carrying the train on Instagram: "Proud friend. Proud mom," she said. The anti-monarchy group Republic held its annual European Republic convention during the day: just about everyone ignored it.

There was debate about the quality of the television broadcasts: the BBC had Kirsty Young, Huw Edwards and Dermot O'Leary (who was criticized for "slouching and mumbling") alongside Alex Jones, Richard Bacon and Ore Oduba. Meanwhile on ITV

ABOVE:

Elated spectators throw confetti as the procession passes by.

OPPOSITE ABOVE:

Revellers at a street party in Chichester enjoy food, drink and glorious sunshine.

OPPOSITE BELOW:

Patriotic colours were everywhere in Windsor, from flags, hats and masks to outfits with matching headscarves.

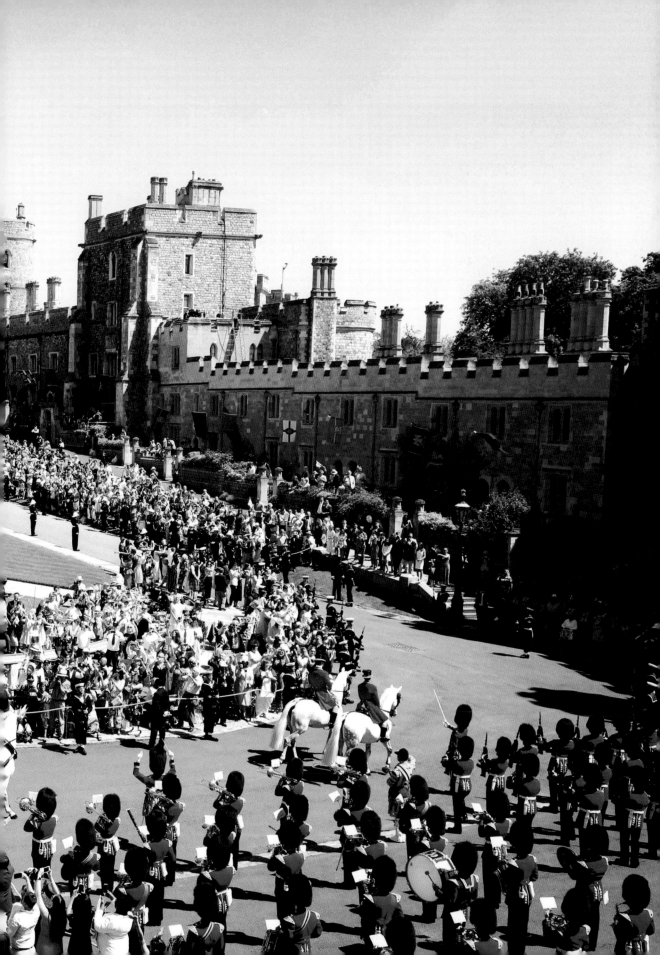

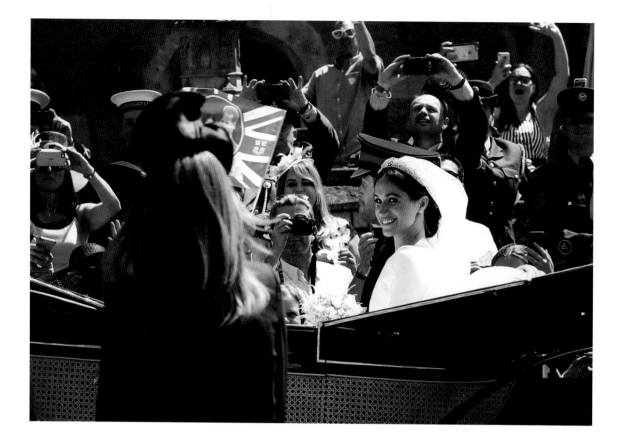

the ever-popular *This Morning* host Phillip Schofield and Julie Etchingham broadcast from a specially built studio in Windsor. Over on Radio 1 Scarlett Moffatt was doing her bit.

Nor was it just the UK that was celebrating: the wedding had a global audience, of course, but there was particular interest in Meghan's home stomping ground of Los Angeles. The British-themed Cat and Fiddle pub in Hollywood welcomed revellers from 2am local time; guests wore fancy dress and the bar staff served traditional British food and drink. The scene was highly emotional, with cheers and applause greeting the kiss outside the Chapel: "I loved it – except for the fact that Harry is now off the market, so my dreams are crushed!" said Alana Hutchinson, 24. "It was beautiful," she continued, "The highlight for me was when Charles walked her down the aisle. I cried a little bit, it was really precious because I know that was such a big deal with her family, so to see her mom out there was really amazing."

ABOVE:

It's cameras at the

ready as Meghan

and Harry embark

on their open-

top carriage ride

through Windsor.

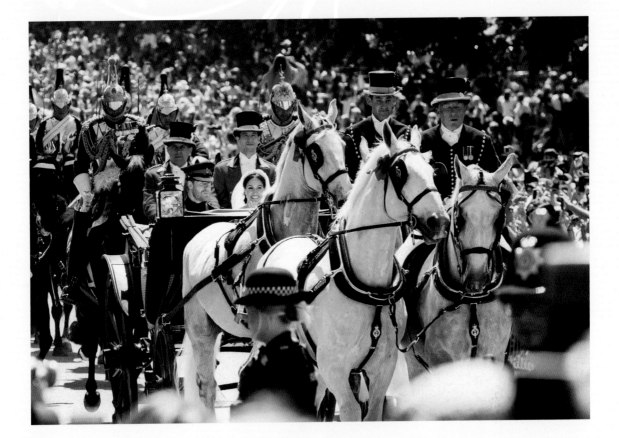

Her fellow locals were equally enthusiastic. Hannah Lucchesi, 22, said, "I loved it, it was amazing, it was beautiful, I loved Meghan's dress and all of the flowers, it was amazing. The highlight for me was Prince George, just because he is my favourite."

And ex-pat Brits enjoyed it too. "The wedding was amazing, I was tearing up," said Claudia Chick, 22, originally from London. "Everyone was dressed beautifully, the ceremony was very passionate and it was different, which is great to see. The atmosphere here was great, everyone was glued to the screen, everyone was laughing together, everyone was crying together."

In the aftermath of the wedding, it emerged that it was actually Prince Charles who had come up with the idea of a gospel choir. "The couple didn't actually ring us at first, the call came from Clarence House. I understand that Prince Charles really likes gospel music," Karen Gibson revealed. "The couple were very intentional about what they wanted sung and how they wanted

ABOVE:

The Royal Ascot Landau carriage is drawn by four Windsor Greys – Milford Haven, Storm, Plymouth and Tyrone.

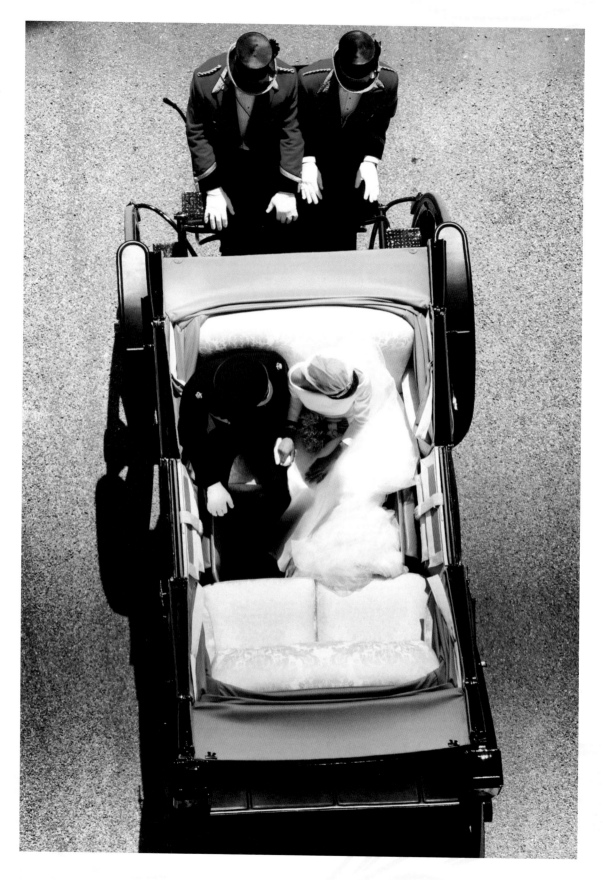

it sung, but the actual idea came from Prince Charles. We want people to get involved, tap their feet, sing along, that's what gospel music is, it's all-embracing and inviting." In reference to modern culture, she added: "We live in a multicultural society, so we had classical music, contemporary classical music as well and gospel music, because you've got many cultures living here so it's reflective of what society looks like today."

And Sheku Kanneh-Mason, who had played three pieces as the couple signed the register, was also waxing lyrical. "It was such an amazing experience actually, and something that I'll remember for a long time," he said. More details came out, including the fact that the Queen had to give Harry special permission to marry in military uniform with a beard.

And the surprise star of the show, the Most Reverend Bishop Michael Curry, was pleased, too: "It was a real joyful thing because there was a sense in which you had the fullness of the church represented in many respects," he said. It had brought people together: "That happened today, in different ways, different

OPPOSITE:

The plush interior of the Ascot Landau carriage, which is so called as Her Majesty the Queen uses it every year for her procession at Royal Ascot.

BELOW:

The Duchess of Sussex wore diamond earrings by Cartier.

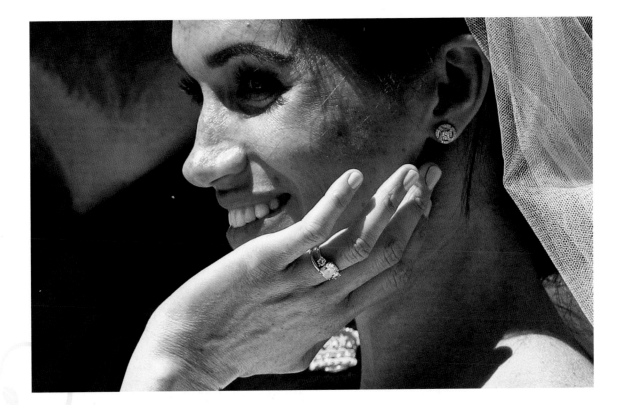

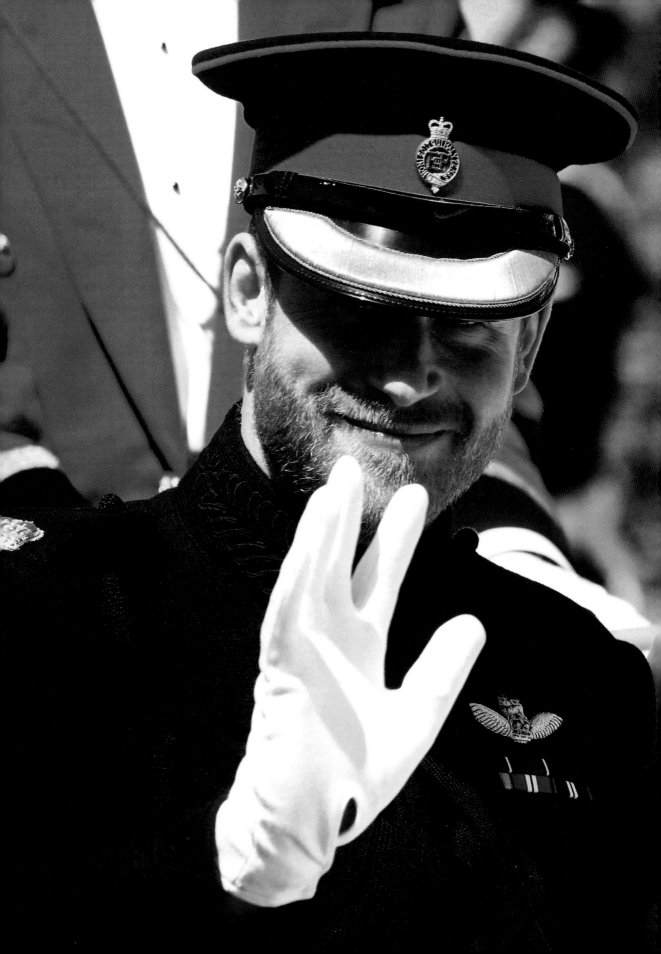

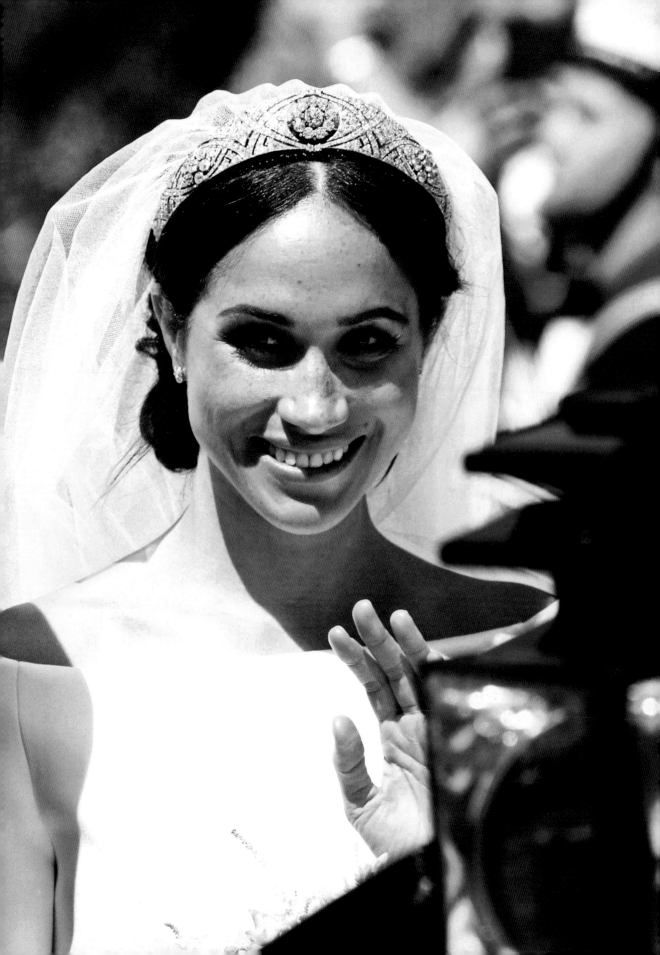

songs, different perspectives, different worlds and all of it came together and gave God thanks." He was asked if it was off-the-cuff or planned. The Archbishop of Canterbury was present at the interview: "Let's have an honest answer," he said, laughing. "It was planned and I thought it was going to be six minutes," said Bishop Curry. "It was a little longer than that because there were pauses in it." Cue more laughter from the Archbishop; goodwill was in abundance absolutely everywhere.

As Harry and Meghan finished their 25-minute carriage procession – "I'm ready for a drink now," Harry remarked – they adjourned to the first of their two wedding receptions. The first, for the 600 people who were at the ceremony, was hosted by the Queen at St George's Hall, a 180-foot-long room often used for state banquets. The walls are lined with suits of armour. Prince William acted as compère and it was here that the speeches were made and the cake was cut.

Guests were served Scottish langoustines wrapped in smoked salmon with citrus crème fraîche, grilled English asparagus wrapped

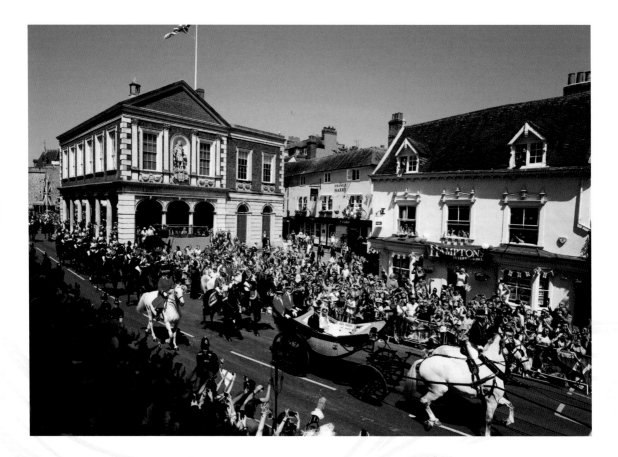

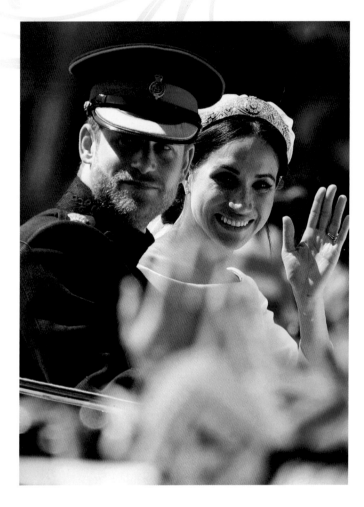

PAGES 144-145:

As the Duke and Duchess of Sussex smile and wave at the gathered well-wishers, their joy is written on their faces.

OPPOSITE:

The streets of Windsor are lined with Royal fans, cheering and waving as four Windsor Grey horses draw Harry and Meghan's carriage on a 25-minute procession.

ABOVE:

Harry and Meghan head back to St George's Hall for their lunchtime reception, hosted by the Queen.

in Cumbrian ham, garden pea panna cotta with quail eggs and lemon verbena, heritage tomato and basil tartare with balsamic pearls, poached free-range chicken in a lightly spiced yoghurt with roasted apricot, croquette of confit Windsor lamb, roasted vegetables and shallot jam and warm asparagus spears with mozzarella and sun-blush tomatoes. They were also served a selection of bowl food, including: fricassee of free-range chicken with morel mushrooms and young leeks, pea and mint risotto with pea shoots, truffle oil and parmesan crisps and ten-hour-slow-roasted Windsor pork belly with apple compote and crackling. And finally there were sweet canapés, including champagne and pistachio macaroons, orange crème brûlée tartlets and miniature rhubarb crumble tartlets. Much was made of the fact that rather than being a sit-down meal, as is more normal on these occasions, the food was served in bowls.

The cake was also a slight break with tradition. Claire Ptak, an east London pastry chef, made an organic lemon and elderflower cake for the celebration. Owner of the Violet Bakery in Hackney, she created a cake incorporating "the bright flavours of spring", according to Kensington Palace, covered with buttercream and decorated with flowers. It featured elderflower syrup, which was made at the Queen's Sandringham residence (where Meghan had spent the previous Christmas with her future in-laws).

The Prince of Wales spoke, talking about his "darling old Harry", remembering him as a baby and so happy that he was marrying the love of his life. He had winded Harry as a baby, he recalled, though he couldn't resist adding that Harry might still have a little wind today. Joking aside, Prince Charles' speech was incredibly moving, and guests also noted how warmly he welcomed Meghan into the family, and made a great fuss of Doria, frequently putting his arm around her to put her at ease.

OPPOSITE ABOVE:

Trombonists entertain the crowd.

OPPOSITE BELOW:

The Household Cavalry on parade.

BELOW:

Clare Ptak crafted a sumptuous lemon and elderflower wedding cake, using elderflowers from the Queen's Sandringham Estate.

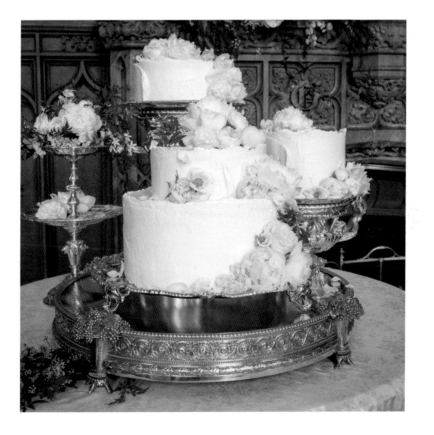

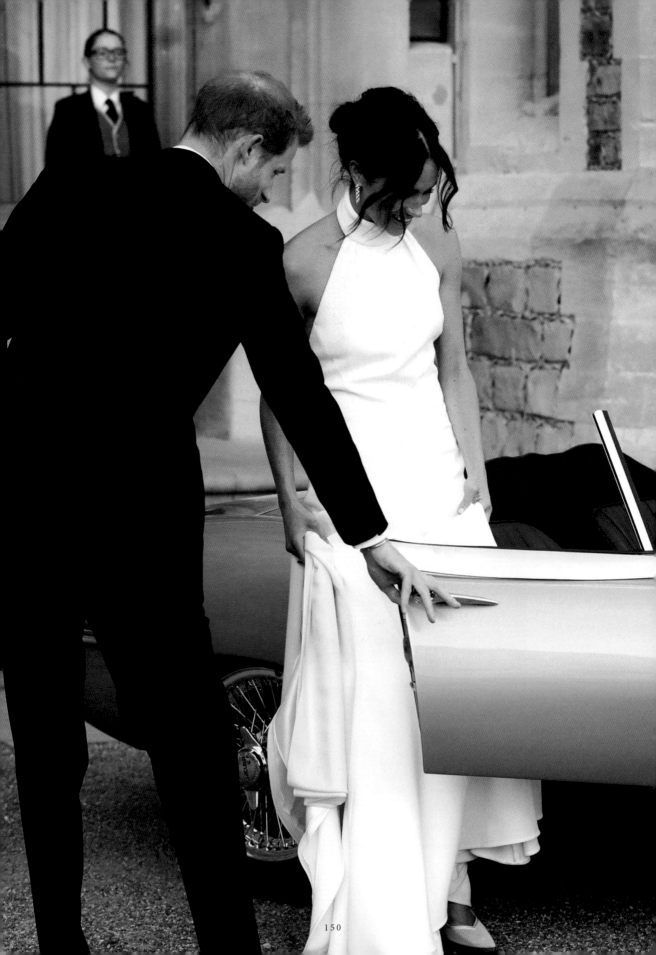

When Harry got up to make his speech, there were cheers as he used the phrase: "My wife and I." One guest revealed: "It was very off-the-cuff, which was lovely. He promised that all the Americans wouldn't steal the swords and said, "Please, when you leave, be quiet as you don't want to wake the neighbours," which was quite fun. It was more than you would ever imagine it to be. It did feel like we were really part of their very special occasion. It just felt about the two of them, which was great." It was also very goodhearted: that quip about the swords got a laugh.

When Harry finished his speech, he asked if anyone present could play the piano. Cue Sir Elton John, who performed for the couple, a poignant moment, for he had also sung at Diana's funeral. "Prince Harry asked Sir Elton to perform at the reception which was hosted by Her Majesty The Queen at St George's Hall, Windsor Castle," Kensington Palace said in a statement. "Sir Elton performed for the newly married couple in recognition of the close connection he has with Prince Harry and his family." The performance included "Tiny Dancer", which he dedicated to Meghan, "Your Song" and "Circle of Life".

Suhani Jalota, the founder of the India-based Myna Mahila charity, was one of the guests and throroughly enjoyed Sir Elton's

ABOVE:

Sir Elton John, who has known Prince Harry since his childhood, was invited by the groom to perform at the first reception at St George's Hall.

NEXT PAGE:

Looking like James Bond stars, the glamorous couple emerge in new outfits, the bride opting for a Stella McCartney gown and Aquazzura heels with blue soles.

OPPOSITE:

A blue Jaguar E-Type Concept Zero was the couple's carriage to their second, more intimate, reception.

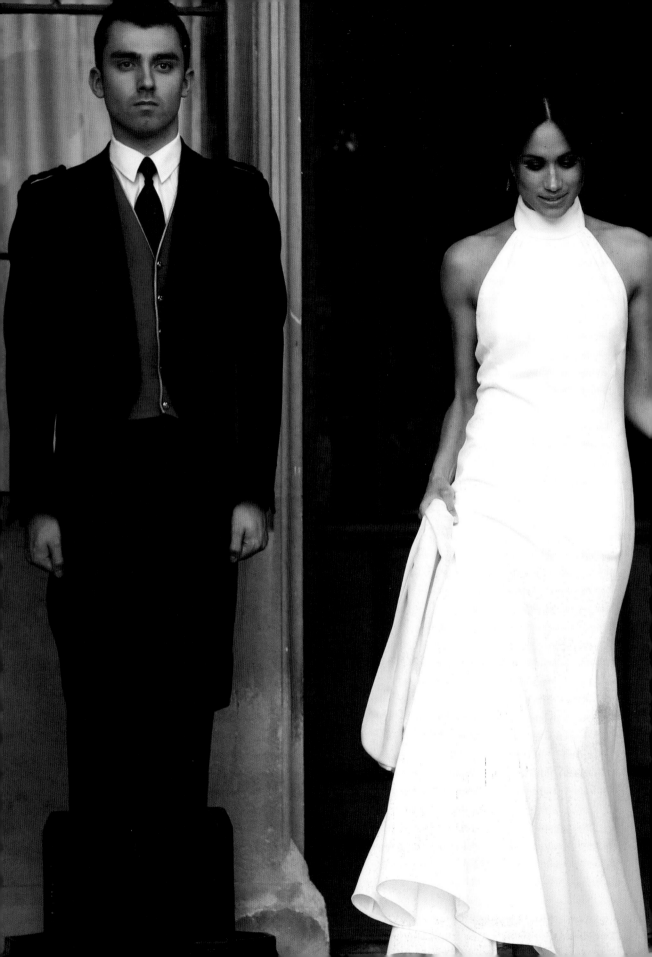

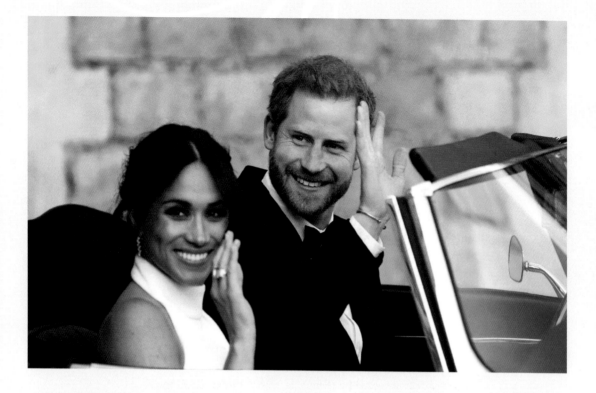

input. "He was incredible. It became like a mini-concert in the reception area. It was great," she said. "[The speeches by Prince Charles and Harry were] lovely – some people were even crying. I think it was just a very, really nice atmosphere to be in where everybody felt really loved. Essentially it was just about how Harry was as a child and growing up. And now just about the couple and how beautiful they are together... their personalities and how they gel really well together. He [Harry] was talking about his wife and everybody was clapping because it was the first time he was using that term for Meghan so it was really nice."

Across the Atlantic, Thomas Markle again spoke to TMZ, the show-business website. "The service was beautiful and it's history," he said. "I will always regret not being able to be there and not being able to hold my daughter's hand. My baby girl is a duchess and I love her so much. When you watch your child get married, every thought goes through your mind, every memory from the first day she was born, the first time I held her. "

The second reception was hosted by Prince Charles at Frogmore

ABOVE AND OPPOSITE:

Along with the shoes and open-top sports car, there was another "something blue" in the form of an emerald-cut aquamarine ring from Princess Diana's jewellery collection, which, poignantly, was a wedding gift to Meghan from Harry.

House, about half a mile away from Windsor Castle in Windsor Home Park. Frogmore House, a Royal residence since 1792, is where the couple posed for their engagement photographs, and it was a much smaller and more intimate reception, with only 200 guests. Harry and Meghan drove to the occasion in a customized E-Type Jaguar with a licence plate referencing the date of the wedding: Harry was in black tie and Meghan looked sensational in a white Stella McCartney halterneck dress that showed off her toned shoulders. She was also wearing a large aquamarine ring that had belonged to Princess Diana.

A dinner party, the second reception featured house music – Harry's favourite – put together by DJ Sam Totolee. The dinner started at 7.30pm, with a theme of "spring meets summer" and there were speeches from Prince William, Tom Inskip and Tom Van Straubenzee. As expected, Meghan broke with tradition to make a speech herself, thanking the Royal Family for welcoming her. Fireworks lit up the night sky over Windsor and candy floss and "dirty burgers" were served as midnight snacks, while one cocktail featuring ginger and rum was called "When Harry Met Meghan". Some of the guests then went on for a final celebration at the Chiltern Firehouse. The next morning Britain woke to a changed monarchy – a very modern one. Prince Harry, once the little lost boy, had finally found his bride.

NEXT PAGE:

The couple left for their evening reception in a Jaguar, with a personalized number plate bearing the date of their wedding.

SELECTED HIGHLIGHTS FROM THE ORDER OF SERVICE

PRAYER

GOD of love,
send your blessing upon Harry and Meghan,
and all who are joined in marriage,
that, rejoicing in your will
and continuing under your protection,
they may both live and grow
in your love all their days,
through Jesus Christ our Lord.
Amen

THE PREFACE BY THE DEAN OF WINDSOR

In the presence of God, Father, Son and Holy Spirit, we have
come together to witness the marriage of HENRY CHARLES
ALBERT DAVID and RACHEL MEGHAN, to pray for God's
blessing on them, to share their joy and to celebrate their love.
Marriage is a gift of God in creation through which husband
and wife may know the grace of God. It is given that as man and
woman grow together in love and trust, they shall be united with
one another in heart, body and mind, as Christ is united with his
bride, the Church. The gift of marriage brings husband and wife
together in the delight and tenderness of sexual union and joyful
commitment to the end of their lives. It is given as the foundation
of family life in which children are born and nurtured and in
which each member of the family, in good times and in bad, may
find strength, companionship and comfort, and grow to maturity
in love. Marriage is a way of life made holy by God, and blessed
by the presence of our Lord Jesus Christ with those celebrating
a wedding at Cana in Galilee. Marriage is a sign of unity and
loyalty which all should uphold and honour. It enriches society
and strengthens community. No one should enter into it lightly
or selfishly but reverently and responsibly in the sight of almighty
God. HARRY and MEGHAN are now to enter this way of life.
They will each give their consent to the other and make solemn

vows, and in token of this they will each give and receive a ring. We pray with them that the Holy Spirit will guide and strengthen them, that they may fulfil God's purposes for the whole of their earthly life together.

LADY JANE FELLOWES GAVE A READING FROM THE SONG OF SOLOMON

My beloved speaks and says to me: "Arise, my love, my fair one, and come away; for now the winter is past, the rain is over and gone. The flowers appear on the earth; the time of singing has come, and the voice of the turtle dove is heard in our land. The fig tree puts forth its figs, and the vines are in blossom; they give forth fragrance. Arise, my love, my fair one, and come away." Set me as a seal upon your heart, as a seal upon your arm; for love is strong as death, passion fierce as the grave. Its flashes are flashes of fire, a raging flame. Many waters cannot quench love, neither can floods drown it. If one offered for love all the wealth of one's house, it would be utterly scorned.

THE ARCHBISHOP OF CANTERBURY BLESSED THE MARRIAGE

BLESSED are you, O Lord our God, for you have created joy and gladness, pleasure and delight, love, peace and fellowship. Pour out the abundance of your blessing upon HARRY and MEGHAN in their new life together. Let their love for each other be a seal upon their hearts and a crown upon their heads. Bless them in their work and in their companionship; awake and asleep, in joy and in sorrow, in life and in death. Finally, in your mercy, bring them to that banquet where your saints feast for ever in your heavenly home. We ask this through Jesus Christ your Son, our Lord, who lives and reigns with you and the Holy Spirit, one God, now and forever, Amen.

GOD the Father, God the Son, God the Holy Spirit, bless, preserve and keep you; the Lord mercifully grant you the riches of his grace, that you may please him both in body and soul, and, living together in faith and love, may receive the blessings of eternal life. Amen

CREDITS

The publishers would like to thank Getty Images for their kind
permission to reproduce the pictures in the book.

All other photographs were supplied by following sources:

Alamy pp.36–37, p.71
Rex/Shutterstock p.28 p.39, p.41, p.48, p.51, p.52, p.59, p.70, p.72,
pp.74–75
Seth Poppel Archive p.31

Every effort has been made to acknowledge correctly and contact
the source and/or copyright holder of each picture, and Carlton
Publishing Group apologizes for any unintentional errors or
omissions, which will be corrected in future editions of this book.